NEW CREATIVITY PARADIGMS: ARTS LEARNING IN THE DIGITAL AGE

Colin Lankshear and Michele Knobel
General Editors

Vol. 70

The New Literacies and Digital Epistemologies series
is part of the Peter Lang Education list.
Every volume is peer reviewed and meets
the highest quality standards for content and production.

PETER LANG
New York • Washington, D.C./Baltimore • Bern
Frankfurt • Berlin • Brussels • Vienna • Oxford

NEW CREATIVITY PARADIGMS: ARTS LEARNING IN THE DIGITAL AGE

KYLIE PEPPLER

PETER LANG
New York • Washington, D.C./Baltimore • Bern
Frankfurt • Berlin • Brussels • Vienna • Oxford

Library of Congress Cataloging-in-Publication Data

Peppler, Kylie A.
New creativity paradigms: arts learning in the digital age / Kylie Peppler.
pages cm. — (New literacies and digital epistemologies; vol. 70)
Includes bibliographical references.
1. Art—Study and teaching (Elementary) 2. Art—Study and teaching (Secondary)
3. Digital art—Study and teaching (Elementary) 4. Digital art—Study and teaching
(Secondary) 5. Creative ability in children. I. Title.
N350.P395 372.5—dc23 2013038190
ISBN 978-1-4331-2514-0 (hardcover)
ISBN 978-1-4331-2513-3 (paperback)
ISBN 978-1-4539-1236-2 (e-book)
ISSN 1523-9543

Bibliographic information published by **Die Deutsche Nationalbibliothek**.
Die Deutsche Nationalbibliothek lists this publication in the "Deutsche
Nationalbibliografie"; detailed bibliographic data is available
on the Internet at http://dnb.d-nb.de/.

Cover design and layout by Nina Wishnok

The paper in this book meets the guidelines for permanence and durability
of the Committee on Production Guidelines for Book Longevity
of the Council of Library Resources.

© 2014 Peter Lang Publishing, Inc., New York
29 Broadway, 18th floor, New York, NY 10006
www.peterlang.com

Printed in the United States of America

Commissioned by

Supporting ideas.
Sharing solutions.
Expanding opportunities.®

CONTENTS

ACKNOWLEDGMENTS

This report wouldn't have been possible without the hard work and dedication of my students and staff. They helped organize the literature; uncover new communities, tools, and ideas; and aid in the initial outline and conceptualization of the field. I owe an immense amount of thanks to:

Michael Downton, for spearheading the literature review on the impact of new technologies on music learning as well as much of the work editing the final draft of the report. Diane Glosson, for providing reviews of manga, comics, animation, and interim deliverables. Rafi Santo, for uncovering the literature on virtual communities, fan fiction, and creative writing and also spearheading our reference organization in Mendeley throughout the process. Kate Shively, for spearheading the literature review on photography, visual arts, and museums, as well as maintaining the appendices and delivery schedule. Maria Solomou, for assisting with the literature review on video games, 3D virtual building and other areas featured in the report. Charlene Volk, for assisting wherever there was a need and spearheading the reviews on visual arts, theater, film, dance, video games, and machinima as well as assistance in other aspects of the report. Cagri Yildirim, for assisting with the literature reviews on media arts and grassroots organizing. Benjamin Zaitlen, for assisting with the dance and DIY literature reviews as well as helping to organize everything in the early stages.

As we were conducting our review, we had periodic email conversations, phone conferences and meetings with notable scholars in the field who were very generous with their time and shared some of their latest research with us, including: Brigid Barron, David Buckingham, Cathy Davidson, Drew Davidson, JoEllen Fisherkeller, David Theo Goldberg, Mike Hawkins, Andrés Monroy-Hernández, Mitchel Resnick, Connie Yowell, plus many others in the field. Thank you!

In addition, we hosted a workshop on the topic of Interest-Driven Arts Learning in a Digital Age through the generous support of The Wallace

Foundation. This meeting was instrumental in our conceptualizations of the field, introduced us to new bodies of literature and ideas, and informed our recommendations. As a result, we would like to thank the following people for participating and guiding various aspects of our review process. Their thoughtful insights and recommendations are reflected throughout the thinking in this report but were particularly instrumental in the conceptions of virtual communities, on DIY efforts and arts learning, and many other aspects of the review. Their collective support for the project has been incredible: Donelle Blubaugh, Donna Cox, Dale Dougherty, Kerry Freedman, Steve Goodman, Erica Halverson, Michelle Knobel, Barry Joseph, Nishat Kurwa, Akili Lee, Dan Perkel, Kimberly Sheridan, and Eric Siegel.

Earlier drafts of this report were reviewed and discussed with Jonathan Plucker, Julian Sefton-Green and David Gauntlett. Their comments resulted in considerable changes to this document, which have sharpened the arguments and made it more intelligible to diverse audiences interested in the broader topic. We are immensely grateful for their guidance and feedback throughout the process. I would also like to thank my partner, Eric Lindsay, who is a relentless supporter, constructive critic, and thorough editor.

Several people who assisted with assembling the final version of this report deserve special recognition, including first and foremost, Pam Mendels and Lucas Held, for their poignant feedback on the second iteration of this document as well as their larger vision. Additionally, I would like to thank Holly Holland, who tirelessly edited several versions of this report to sharpen and broaden the arguments. In addition, I'm incredibly grateful to H.J. Cummins and Janis Watson, who assisted in compiling the references and the final copyedits of the report.

This review was commissioned with generous support from The Wallace Foundation. A special thanks again goes to Mitchel Resnick for putting the Foundation in contact with me for this opportunity. Lastly, I am incredibly grateful to the Director of Arts at the Foundation, Daniel Windham, for his initial vision that precipitated this review as well as his insightful questions, thoughtful conversations, and assistance throughout the review process.

EXECUTIVE SUMMARY

Traditionally in the United States, schools and after-school programs have played a prominent part in teaching young people about the arts. Arts education has been waning in K–12 public schools in recent times, however. This is especially true in low-income communities, where public schools have often cut back on arts instruction so they can devote limited public education dollars to subjects such as writing and math that are the focus of high-stakes standardized tests.

When we look outside of school, however, we see a strikingly different landscape, one full of promise for engaging young people in artistic activity. What makes this landscape possible is an eagerness to explore that springs from youths' own creative passions—what we call "interest-driven arts learning"—combined with the power of digital technology.

This report is a step in trying to understand the new territory. It gives a rundown of scholarship in the areas of arts and out-of-school-hours learning; offers a framework for thinking about interest-driven arts learning in a digital age; examines young people's media consumption; provides a survey of youths' creative endeavors online and elsewhere, along with a look at the proliferation of technologies that young people are using in the arts; and concludes with thoughts about challenges and possibilities for the future.

A Framework for Thinking About Interest-Driven Arts Learning

To date, much of what we know about arts learning comes from examinations of education in school. A widely cited study on the unique characteristics of arts learning is the "Studio Thinking Framework," which describes and analyzes eight habits of mind cultivated in high-quality visual arts classes. There are likely similarities between what students gain in such formal settings and what they gain in interest-driven arts learning. However, applying what we know about classroom learning to interest-driven learning falls short because of their dissimilarities.

Three differences are especially important. The first is that interest-driven art-making and performance, especially creations that employ digital technologies and refer heavily to popular media, are inherently inter-disciplinary, that is, they use more than one art form. The second is that young people produce self-directed arts projects solely because they want to; they are motivated not by what outsiders think or want, but by the young person's own pride in the work and curiosity or passion for the medium. Interest-driven arts projects, then, may offer valuable insights about what makes youths engage and persist in arts activities. Third, interest-driven art-making is fueled to a large degree by the surge in new technologies, which have radically transformed the ability to collaborate, share and publish work, affecting the modes, genres, and ways of art-making today.

Taking all this into consideration, we suggest in our report a framework that might be used for thinking about what students can gain from interest-driven arts learning. Our framework has four main parts—each a distinct "practice" that can be cultivated by interest-driven arts learning in a digital age:

- technical practices, such as computer coding for artistic projects;
- critical practices, such as carefully observing and studying an artwork to understand it;
- creative practices, such as making choices how to handle a project by applying artistic principles; and
- ethical practices, such as giving credit to the original creators of a work.

Media-Absorbed Teens and Interest-Driven Arts

It goes almost without saying that kids today are absorbed in computers, cellphones, video games, television and other media—spending an average of 7 hours and 38 minutes a day with the gadgetry, according to a report by the Kaiser Family Foundation. Additionally, because youths multitask, using more than one medium at a time, they are actually packing 10 hours and 45 minutes worth of media consumption into those 7.5 hours.

At the same time, many young people are creating original work and sharing it with others. This is happening in physical spaces through popular events such as comics and costume ("cos-play") conventions, as well as

in displays of homemade projects at "Maker Faires" sponsored by Make magazine. It is also happening online. Findings from the Pew Internet & American Life Project suggest that nearly two-thirds of online teens create content at some point—from blogs to Web pages to original stories, photos, videos or other artwork they post electronically.

What other creative activities are young people engaging in in their "spare" time? A wide variety of traditional endeavors, to be sure—dancing (often assisted by video games or websites) or poetry (given new life by poetry slams), for example. But they are also busy at work in many wholly new art forms or hybrids of older forms. Among these are designing video games; using animations or cartoons or video game components to produce "machinima" films; and generating "fanfic," stories and creations that feed off popular books, movies, cartoons and other features.

All this, we believe, points to a broader cultural trend that values creative production and the communities that form around it. This trend is driven in part by the proliferation of technologies that put production of arts—music composition, dance, design, and visual arts, among them—within reach of anyone interested. A very short sampling of these technologies gives an idea of the breadth of what's available. Scratch, a visual programming environment, allows people to create and share interactive animations, video games, music and art, while the popular GarageBand software enables novices to compose original music without traditional instruments or access to recording studios. The Brushes app for iPads enables painters to mix paint without paying for new materials or having taken an art class; the Arduino microcontroller helps artists and designers create their own robotic sculptures or interactive environments.

Communities for Arts Learning— Virtual, Physical and Both

The Web; social media outlets like Twitter, YouTube, and Facebook; and many online communities specifically for artists are giving young people places where they can post digital portfolios, as well as view and comment on one another's work. At the same time, arts mentoring communities are

emerging, in some cases taking the role of instructor, especially for arts not usually taught in K-12 schools, such as manga and video game design.

Some communities that form around creative production are virtual: deviantART, for example, is a large online site where artists can share, discuss and market their work, while MacJams serves as an online studio for musicians.

But a number of promising communities focused on young people and artistic production have emerged in physical spaces, too. The YOUmedia network, a program for young people to learn new media skills, is based in libraries, museums and community organizations, for example. The Computer Clubhouse Network, which provides media arts experiences to teens, operates through a network of freely available after-school, open studio spaces.

What we call "grassroots movements" also have the potential to be potent means of arts learning through involvement in communities. Take "krumping," an urban dance form that originated in south central Los Angeles. Membership in Krump communities is dependent on one's inclusion in "families," which are organized around mentorship from a more experienced Krump dancer. The form evolves when large groups of dancers engage in "battles" or other exhibitions, after which dancers and their families incorporate or respond to the newest moves from the event. This ensures the perpetual development of the dance form.

In some cases, arts learning communities are both virtual and physical. In addition to concrete meeting spots, YOUmedia offers teens access to Remix Learning, an online space to support mentor-student and student-student collaborations beyond the school day and after-school classes. Remix Learning allows users to post text, graphic designs, games, and videos; exchange ideas; critique work; share expertise; and debate. Online mentors (artists hired as staff by YOUmedia) encourage youths to post their work while also demonstrating model behavior by posting their own creations and moderating online discussions and competitions.

Remix Learning amounts to what we call a "social learning network" (as opposed to a "social network" like Facebook), but because such communities have not been heavily studied, we still have much to learn about how they

could boost arts learning. For example, we don't know if youths who have already had experience working with a mentor at a community center do better in social learning networks than the uninitiated. Similarly, grassroots communities have engendered little formal research, although what research there is suggests that most of the eight Studio Thinking habits of mind are taking place within them, from developing craft to reflecting on the process. See the appendices of this report for a comprehensive review of communities, apps, and online platforms to support interest-driven arts learning.

Adjusting Instruction to Teens' Level of Interest

To increase youth participation and interest in the arts, adults need to recognize that not all teens are alike—some already have a great interest in the arts, some none at all—and design programming accordingly.

That's what Musical Futures, a British arts education project, has done. The organization has come up with a classification that divides young people into four categories: refusers, those with little or no interest in music; waverers, who have an interest in music but are unsure what they want to do or how to participate; explorers, who have some skills and confidence but have not yet found a good match for their interests; and directors, who are already performing. The project develops fitting activities for the various groups—"taster" workshops for waverers, for example, or professional recording sessions for the directors.

Musical Futures' approach, which seeks to understand young people and meet them where they are, offers insight into how to invite young people into the arts and sustain their participation over time.

Challenges and Possibilities

We conclude the report with discussion of five challenges to, and subsequent opportunities for, interest-driven arts learning in the 21st century: (1) conceptualizing interest-driven arts learning in new media, (2) changing adults' perceptions of youths' interest-driven arts activities, (3) promoting equity in interest-driven arts learning opportunities, (4) designing interest-driven arts learning social networks, and (5) inviting, sustaining, and supporting participation in arts activities. For each of these areas, we offer

suggestions for future research, practice, and policy that build on what we know about interest-driven arts learning to enable more youth, particularly disadvantaged youth from non-dominant communities, to learn about and participate in the arts.

A few of the possibilities are:

- *Use technology.* Embrace new technologies to locate youth interested in the arts. Then connect them to helpful online resources. Among them is the Kickstarter seed-financing site, for small grants to encourage youths' art-making.
- *Encourage portfolio practices.* Encourage youth to document what they have created, and design new portfolio systems that make it easy for youth to collect their work over the years.
- *Expand successful learning projects.* Use organizations like the Computer Clubhouse Network and YOUmedia as models to build a national infrastructure for supporting youths' interest-driven arts participation, particularly in non-dominant, rural, and urban communities.
- *Make the most of social media.* Use social networking to, for example, invite young people to display their work in curated exhibits online.
- *Invest in research.* Expand the knowledge base, particularly research regarding how young people can be brought into lifelong participation in the arts, whatever their individual interest and artistic ability.

INTRODUCTION

THE RESOUNDING VOICE
OF YOUTH IN A DIGITAL AGE

The emergence of digital media in the past decade has enabled what is widely seen as a democratization of knowledge, a movement in which collective intelligence and quick access to information may supplement or even surpass the role of formal education. The ability to merge self-expression and mass communication has given youths who have grown up during this era of transformative technology new ways to create, learn and share—often without the assistance or direction of adults. Perhaps no area has been as influenced by these changes as the arts. With the appeal of music, visual and interactive media to youth culture, the arts have opened new paths to civic participation, learning, and entrepreneurship. Some examples:

"A Place to Express Yourself"

In 2004, 14-year-old Ashley Qualls took her interest in graphic design to the Internet to create Whateverlife.com, a source for MySpace graphics and Web design tutorials. She described the site as "a place to express yourself." In addition to layouts and other free graphics, Whateverlife.com now features a magazine with teen-authored articles and reviews. According to Google Analytics figures, Whateverlife attracts more than 7 million individuals and 60 million page views a month (Salter, 2007).

A Rookie's Industry Clout

Fashion blogger Tavi Gevinson surprised her parents when she asked their permission to appear in a *New York Times Magazine* story about the "Style

Rookie," the website she had launched two years earlier, at age 11. "Rookie" now has more than 50,000 subscribers, and Tavi's commentary is widely recognized and respected within the fashion industry. She has collaborated with fashion artists around the world and has been featured in several leading fashion magazines.

From Video Games to Violin Lessons

Rhythmic video games such as *Rock Band* are changing the way young people learn foundational music concepts and notation (Peppler et al., 2011). Stepping into the shoes of the onscreen musicians motivates youths to learn the real skills that will enable them to play independently. Asked why he had signed up for free violin lessons after playing *Rock Band* at an after-school club, an 11-year-old boy replied, "I want to learn guitar, and if I can do this (mimics the playing of a violin), then I can do this (mimics the playing of a guitar)" (Peppler et al., 2011, p. 1).

Tw1tterBand

Youth rock band rehearsals are moving out of the garage and into cyberspace. Tw1tterBand, a group of 11 people who have never met in person but who share an interest in music and philanthropy, formed a band through the social media network, Twitter, and released singles and videos that have helped raise money for charitable organizations.

Challenges and Opportunities of Interest-Driven Arts Learning

The previous vignettes demonstrate what we will refer to in this report as "interest-driven" arts learning—a form of participation where youths research and learn about their creative passions and hobbies, connecting them to peers with the same interests who may extend beyond their immediate social circle. Often communities of interest-driven youths are widely distributed, connected by social networking platforms such as YouTube and Facebook. Because shifting technology trends move at a substantially faster rate than curricular changes, ethnographic research consistently shows that

youths are gaining most of their knowledge and competencies in and through new media outside of schools (Hull & Schultz, 2002; Ito et al., 2010). The social aspect of this learning is paramount; scholars such as Rebecca Black (2008), David Buckingham (2003), Andrew Burn (2008), Julia Davis and Guy Merchant (2009), James Gee (2003, 2004), Henry Jenkins (2006), Marc Prensky (2006), Katie Salen (2008), and Constance Steinkuehler (2008) have described how online resources link individuals with similar interests (affinity groups, as James Gee would call them [2003]) and make possible modes of learning and communicating that differ from conventional schooling.

At the same time, learning theorists such as John Seely Brown and Richard Adler (2008) describe the resulting shift from a "push" approach of education, where schools push the learning of particular content, to a "pull" approach of social learning, where new technologies enable people to pull information when they want to solve particular problems at particular times. Moreover, this switch enables youths to move from "learning about" a particular subject to "learning to be" an active participant in the field (Seely Brown & Adler, 2008, p. 18). Within the arts, this shift suggests a movement from pushing high art forms to one that pulls youths to participate in the arts through their interest-driven activities.

Changes are occurring not only to the tools and modes of arts participation, but also to artistic practices, processes, and products. As David Gauntlett (2011) suggests, people engage with the world and create connections with each other through making things. This is certainly true of interest-driven arts communities, where youths are creating work from diverse materials and sharing with a worldwide community. By highlighting the diversity and depth of young people's art making, we want to discuss the divide between teenagers' media consumption, production, and participation and their involvement in the arts. We also aim to showcase programs and movements that are successfully (re)engaging learners in the arts field as a whole.

Digital technologies have transformed how and what young people create. One of the most notable examples is the field of game design. To some scholars, video games present a new literacy that is as important as text in learning to read and write today. The field of games studies has been rapidly expanding since the mid-1990s to define what is learned from reading or

playing games (Gee, 2004) as well as from writing or designing video games (Kafai, 1995; Salen & Zimmerman, 2003; Peppler & Kafai, 2010). We discuss examples like these later in this report to help readers from the arts and arts education fields understand how young people are using digital media to learn about and through the arts today.

Through interest-driven arts production, youths engage in a continuum of practices ranging from non-artistic to highly valued arts. Research has documented these emerging creative communities, but mostly on the media production side. Fewer scholars have investigated whether and how youths intentionally engage in the arts. What we know about arts learning within the discipline comes to us from high-quality classrooms that emphasize the visual arts (Hetland et al., 2007). Seeking to extend what we know about creative digital cultures *beyond* schools, we offer a new framework for exploring interest-driven arts learning.

The significance of this work is twofold. First, we seek to draw attention to the contributions that young people are making in the arts, accomplishments that could spur changes in industry, culture, and public policy. Because these interest-driven initiatives fall outside the traditional scope of arts education, there is a tendency to dismiss their importance and neglect opportunities to link young people's interest in digital technology to learning other subjects and becoming innovators instead of just consumers of media.

Second, technology has the potential to open doors to young people who have historically been left behind in education. Access is the key. In the United States, schools and after-school programs have traditionally played a prominent role in the cultural transmission of arts learning. However, standards-based education reform has markedly affected the availability of arts education for most public school youth. This is particularly true in low-income school communities, which often adopt remedial curricula in the pursuit of higher standardized test scores. Visual and performing arts programs in low-income schools are hit particularly hard (Parsad & Spiegelman, 2012), despite research that suggests that disadvantaged students benefit especially from high-quality arts education (Catterall, Dumais & Hampden-Thompson, 2012). Given tremendous budget pressures that

states and school districts expect to face in the next few years, arts educa-
tion nationwide is likely to incur further cuts before this trend is reversed.

A Doorway In

Although conventional schooling presents diminishing opportunities for
arts learning for many youths, the landscape of informal, interest-driven
learning is strikingly different. The out-of-school hours are dominated by
self-directed activities of teens that are rooted in everyday forms of creativ-
ity (Ito et al., 2010; Knobel & Lankshear, 2010; Gauntlett, 2012). Teenagers
are avid consumers of the arts and media, especially those that incorpo-
rate new technologies, as evidenced by the proliferation of music uploads/
downloads on mainstream sites like iTunes or personal Web pages, social
networks like MySpace or Facebook, or from ever-increasing consumption
of movies, video games and Web applications. The Kaiser Family Founda-
tion report, *Generation M²: Media in the Lives of 8- to 18-year-olds*, shows that
the appeal is universal among high-school-aged youths, regardless of race or
class (Rideout, Foehr, & Roberts, 2010).

At the same time, the lines between consumers and producers are being
blurred, what scholars refer to as the new participatory culture (Jenkins
et al., 2009). The extent to which youths can move fluidly between con-
suming and producing media is a byproduct of widely available creative
tools and platforms that enable them to experiment with technology that
was previously the exclusive domain of professionals (Buckingham, 2003).
Young people are creating a diverse amount of media, including podcasts
(Soep & Chávez, 2005), digital photos (Merchant, 2010; Potter, 2010), music
videos (Knobel, Lankshear & Lewis, 2010), original music compositions,
and animation (Luckman & Potanin, 2010; Thomas & Tufano, 2010), and
some studies suggest that nearly two-thirds of teens are creating content
(Lenhart & Madden, 2007). This type of media production, while not inher-
ently rooted in the arts, denotes a "creative turn" (Sefton-Green et al., 2011)
in our uses of new technologies.

We should note here that art is being used to describe two very different
philosophical viewpoints. Art with a capital A usually refers to those genres
and works at the center of formal arts curricula, embodiments of highly

valued creative practices, pedagogies and movements transmitted culturally between generations. Art with a lower case *a*, on the other hand, includes modes of expression that, while meaningful to its creator, can fall outside of the aesthetic perimeter of formal institutions.

We envision an ecology of creative production that would integrate non-arts media production (such as posting photos to a website), art with a lower case *a* (such as making a music video) and Art with a capital *A* (such as fine arts subjects offered in schools). We believe that knowledge from one sphere can inform or motivate decisions in another, giving us a way to start measuring and encouraging participation in the arts. In our opinion, it is far less important to define art than to figure out how we can use interest in media production to create a "doorway in" (Wiggins, 2009) to arts learning. Additionally, we see opportunities to show more youths how to become creators of their own media and art while also learning how to be critical and active participants in an artistic society.

Out-of-school, interest-driven settings are actually well suited to the types of long-term, project-based production and participation that we value in the arts. Part of our investigation includes measuring the success of digital grassroots movements, online communities and the like to engage youths in art. Addressing enduring issues of equity, particularly for marginalized youths, is especially important. Scholars such as Henry Jenkins (Jenkins et al., 2009) and Mark Warschauer (Warschauer & Matuchniak, 2010) argue that equity is not just about access to digital tools and technology but also about opportunities to experience a variety of digital platforms and see their potential. See the appendices of this report for a comprehensive review of communities, apps, and online platforms to support interest-driven arts learning.

Scope of the Review

This review is based on a seemingly simple premise: New technologies are offering unprecedented opportunities for youths to create and participate in the visual, performing and new media arts through computer applications, video game consoles, mobile phones, and online communities across a variety of informal settings. It is imperative that we research the influence and potential impact of these tools and resources to:

- help us understand and validate a range of arts learning experiences
- help us theorize about and conceptualize learning in the arts during the out-of-school hours
- suggest strategies for how we might support and sustain interest-driven arts learning in a digital age.

THE IMPORTANCE
OF ARTS LEARNING

The arts, particularly the new digital arts, play a central role in empowering youths—how they see themselves, how they learn about the world, and how their work can impact the broader socio-political landscape. This perspective is especially important in an age where social networks and online communities provide widespread distribution of youth perspectives (Jenkins et al., 2009; Shirky, 2008). In addition, because new tools and technology make it easy to infuse media artifacts into original work, art is a means through which youths can express their views on matters of concern to their lives and communities (Freedman, 2010; Peppler, 2010a; Greene, 1995).

The educational philosophy known as constructionism, developed by MIT Professor Seymour Papert (1993), focuses on learning that is mediated by the design and creation of personally meaningful objects as well as the interactions that individuals have with others about their work. Although often applied in math and science contexts, the tenets of constructionism, when applied to arts learning, help explain what makes the creation of art such a powerful way of learning and engaging in the world. Papert was a student of Jean Piaget, the father of constructivism (Kafai, 2006). Similar to proponents of constructivism, constructionists assert that learning is an active process in which people actively construct knowledge from their experiences in the world and revise existing ideas of how things work through processes known as assimilation and accommodation. These processes de-

scribe how people actively build mental models of how the world works through interacting with their environment. In other words, "people don't get ideas; they make them" (Resnick, 2002, p. 33).

Theories of constructionism further assert that people construct new knowledge particularly when they are engaged in designing and sharing an artifact within a community. Papert argues that the artifact becomes an "object-to-think-with," an internalized mental structure that comes from physical experience including creating a sculpture, composing a song, writing a poem, or programming a computer animation. What's important is that learners are actively engaged in creating something that is meaningful to themselves and to others around them (Resnick, 2002). Papert's insights lay the foundation for a number of pedagogical approaches and new technologies dedicated to creative production, including the LOGO programming system (Papert, 1980), Scratch (Resnick et al., 2009), Modkit (Baafi and Millner, 2011) and the consultancy process, LEGO Serious Play (Gauntlett, 2007), among many others and have direct applicability to arts education today.

Similar sentiments are voiced in the writings of John Dewey, who asserted that art is proof that people use materials with the intent to expand their lives as well as communicate emotional experiences with others. According to Dewey, "[A]rt denotes the process of doing or making," and provides a tool by which we search for meaning (1934/1980, p. 47). Dewey described the mechanism of shared meaning and emotional impact through art as the experience of aesthetics (1934/1980). According to Dewey, the aesthetic has the capacity to stimulate the imagination and "denotes the consumer's rather than the producer's standpoint" (1934/1980, p. 47). Dewey sees the transformative nature of the aesthetic in challenging the status quo and the dominant elite in order to meet the needs of democratic society. This is particularly relevant to youths in marginalized communities because they have an opportunity to write their own narratives and insert them into the dominant discourse. For non-dominant youths, this can be an empowering and additionally motivating activity because it enables them to develop articulated positions on issues of relevance to themselves and their communities, as well as, through the dissemination and sharing of their work

(a central aspect of learning and producing art in a digital age) engage in a forum where they can express and develop their ideas and identities.

Arts as a Means of Learning about the Self, the Group, and the Other Cultures

Although also supported to various degrees in higher levels of math and science, another key contribution of the arts is that it provides opportunities for multiple solutions. As Elliott Eisner states, "Standardization of solution and uniformity of response is no virtue in the arts. While the teacher of spelling is not particularly interested in promoting the student's ingenuity, the art teacher seeks it" (2002, p. 1). The diversity of solutions and the space that is afforded for creative solutions to a problem is at the heart of what it means to engage in learning in the arts. The valuing of multiple solutions

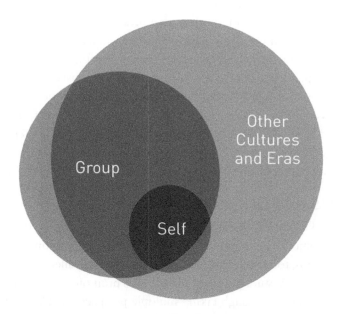

Figure 1.1 A Model of Arts Learning Across Multiple Levels (Peppler & Davis, 2010)

is essential to allowing individual differences to emerge and engender a discovery learning process that engages the learner in learning about the self, the group, the community, and diverse cultures. In fact, prior studies in arts education can be grouped into three broad levels of learning, which are further summarized below and are unique to the arts.

Arts and Learning about the Self

Helping us to better understand the central role of aesthetics and imagination in the artistic process, Maxine Greene's work, *Releasing the Imagination,* stresses that when a young person's imagination is not released he or she may have difficulty situating the self as well as the role of the self in a larger community (1995). Shirley Brice Heath and Elizabeth Soep expand on this to elaborate that the arts allow individuals to be reflexive about the self as they hone their ability to make things of value to their surrounding communities (1998). Running through both of these views is the recognition of art as a vehicle through which individuals can understand their place and contributions to the world, forging identities to uniquely seek solutions to problems, to deal creatively with new phenomena, and to foster insight from within (and not just respond to "outer-direction"). James Catterall and Kylie Peppler also discuss the impact that the arts have on general self-efficacy in disadvantaged groups—the positive and authentic view of one's capabilities and achievements—developed in mastering an art form, and the critical and reflective dispositions that accompany its development (2007). Taken together these strands of research call for future investigations into the differing effects of the arts experience for the audience and the artist.

The Arts and Group Learning

Current and historical research points to the arts as one of the foundations of a democratic society, including effects of the arts on positive social interactions, tolerance, and consideration of moral dilemmas (Catterall, 1995). For instance, studies suggest that the arts promote empathy, tolerance, and solution finding through taking multiple perspectives (Catterall, 2002). These effects may not just extend to students involved in the arts; they may well impact participating teachers and the development of a positive classroom and school identity (Noblit & Corbett, 2001).

The Arts and Cross-Cultural Learning

The arts encourage youths to identify more deeply with their own cultures and share this understanding with others (Wootton, 2004). James Catterall and Kylie Peppler discuss the positive impact that the arts have on disadvantaged youths—particularly how artistic expression gives them an authentic view of their capabilities and achievements in mastering an art form and the critical and reflective dispositions that accompany its development (2007). Moreover, youths from diverse backgrounds can gain deeper understanding about race, culture, and class systems through art (Deasy, 2002). Conversely, young people who lack opportunities to release their imaginations in this way may have difficulty finding their place in the larger community (Greene, 1995).

Because the arts can influence multiple levels of meaning, they give creators a rarely afforded power of public voice. Consider Picasso's *Guernica,* the painter's outraged response to bombing practices that devastated the Basque town of the same name, which brought the world's attention to the Spanish Civil War and subsequently became an anti-war symbol. More recently, modern dance has demonstrated its capacity to draw awareness to issues of import to local communities; consider the South L.A. "Krumping" culture, which was popularized through the documentary *Rize.* This dance form has not only provided an outlet for teens to express their deep dissatisfaction with police brutality but also has become a worldwide movement, extending the canon of contemporary dance.

Learning What Matters

In an era of high-stakes tests and narrowed curricular focus, researchers have concentrated on the transfer of arts learning to other academic domains and social outcomes (Catterall, 2002). Needed now are richer descriptions of the unique benefits of *arts learning* for its own sake. Seeking to add to the field, Lois Hetland and colleagues describe and analyze the unique habits of mind cultivated in visual arts classes (2007). Using longitudinal data from an ethnographic study of five exemplary high school visual arts classes, including more than 4,000 videotaped interactions among teachers and students, the researchers identified eight habits of mind or practices that effective art teachers seek to cultivate. Called the "Studio Thinking Framework," these

attributes show the depth of thinking, application of knowledge, and creative expression that are hallmarks of mastery learning in any subject.

Although this work lays a foundation for future studies in arts education, there is also a need to extend it to the domain of informal, interest-driven arts learning, particularly because creative productions increasingly are designed and distributed through digital channels (Sheridan, 2011). What's called for is a general framework for understanding, analyzing, and appreciating interest-driven art learning that usually occurs outside the classroom. Although this new framework would build on the methods and insights of studio thinking, it should not be rooted in any single discipline. Ideally, it would be general enough to incorporate many different art forms and also be rooted in the experiences that are important to and recognized by youth culture.

Three important factors support the need for such a framework:

1. Informal art making and performance, especially creations that employ digital technologies and heavily reference popular media, are inherently interdisciplinary, moving away from a disciplinary approach to the arts (Peppler, 2010a/b). As youths create these forms of art, they report pulling from across visual arts, dance, drama, design, and music into a single creation, viewing the new work as both a performance and visual product (Peppler & Kafai, 2007b).

2. Youths engage in self-directed arts projects solely because they want to (Gauntlett, 2011). Absent extrinsic motivators to complete a project other than personal pride in the work and a curiosity or passion for the medium, interest-driven arts projects may offer valuable insights about what makes youths engage and persist in arts activities.

3. Interest-driven arts learning is fueled by new technologies. This radically transforms not only the practices and possible genres of art making, but also the experience of viewing art. New technologies have transformed the ability to collaborate, share and publish original work, as well as place a new emphasis on the kinds of technical competencies that artists need to possess to produce cutting-edge work in the 21st century. The extents to which these online practices differ from their forbears have yet to be fully explored or understood.

A Framework for Interest-Driven Arts Learning

Seeking to address this need, we offer a new way to frame youths' interest-driven arts learning in a digital age. At its core, this framework is cross-disciplinary—and perhaps *anti*-disciplinary—moving us away from traditional notions of isolated disciplinary learning toward focusing on learning at the intersection of several related participatory competencies (Kafai and Peppler, 2011). These creative intersections and the blurring of previously distinct modes of participation and learning are trademarks of our increasingly digital society. As youths engage in new media, they are not just participating in the arts but also in multiple literacies and communities of interest, ranging from the arts, media studies, computer science and information studies (New London Group, 1996; Guzzetti & Yang, 2006; Knobel & Lankshear, 2010). We believe youths' creative media production involves technical, critical, and ethical practices that are needed for full participation in interest-driven arts learning.

Technical Practices

Analyses of interest-driven communities reveal that youths' contributions exhibit technical competencies that often include learning computer education concepts and skills (e.g., sustained reasoning, managing problems and finding solutions, and using graphics and/or artwork packages to creatively express ideas) as well as high-level skills such as algorithmic thinking and programming (Cunningham, 1998; diSessa, 2001; Maloney et al., 2008). We have identified in Figure 1.2 three central technical practices important to youths' interest-driven arts learning: *coding* (a significant building block for understanding how digital media is designed, as well as an increasingly important venue for originality and expression in digital media [Malan, 2006; Maloney et al., 2008]), *debugging* (practices of persisting when confronted with technical problems [National Research Council, 1999]), and *remixing* (the practice of reusing earlier ideas to build upon in subsequent work [National Research Council, 1999]).

Interest-driven online communities publish a great deal of work on tools, techniques, and instructions on how to learn basic programming (e.g., makezine.com, instructables.com), so it's not surprising that technical practices have long-since guided these informal discussions. In the context of

artistic production in digital communities, learning to computer program is often a central component of becoming "software literate." This type of creativity with technology is at the core of what professionals are able to do with new media, and it overlaps with what Brian Smith, associate professor of Information Sciences & Technology and Education at the Pennsylvania State University, describes as "computational flexibility" (2006). Being computationally flexible builds upon literate practices involving knowing how to use computationally rich software (e.g., word processors, spreadsheets, and presentation tools) as well as develop fluency (i.e., knowing how and why existing tools do not meet current needs), but extends this to include the ability to create the tools that one can otherwise only imagine.

Critical Practices

As youths begin to take advantage of living in a digital world by capitalizing on the wealth of images, sounds, and videos accessible as "materials" to reuse in their own work, they are given opportunities to critically reflect on and evaluate media texts, leverage references made in popular texts, and deconstruct and interpret the meaning behind such texts (Buckingham, 2003; Buckingham & Burn, 2007; Peppler & Kafai, 2007a). By observing the critical practices of youths' interest-driven arts production in this way, we gain an understanding of the extent to which young artists understand and question the popular texts that they incorporate in their work, apart from what they learn about software programming and new media. We have identified in Figure 1.2 three central critical practices important to youths' interest-driven arts learning: *observing and deconstructing media, evaluating and reflecting,* and *referencing, reworking and remixing.*

In education today, one must arguably deal with the pervasive contemporary visual culture familiar to young people. Learning how to appropriately remix (Perkel, 2006; Erstad et al., 2007) and rework popular media is key to developing analytical thinking. In our prior work, we've found that much of youths' creative media production in new media has entailed a great deal of reworking or remixing of popular media texts such as video games and music videos (Peppler & Kafai, 2007a/b) and further that this "remixing" of popular texts led to sustained creative media production over the

course of several days at an after-school center (Peppler, 2007). This work demonstrated that youths who made reference to popular culture texts in their work (i.e., Beyoncé, Bart Simpson, Chris Brown) were far more likely to persist in creative media production than those who did not reference such texts (Peppler, 2007). By observing the process through which youths transform from consumers to creators of new media, we can assert that it's not just in the consumption of media but also in production that youths develop a critical lens of popular culture.

Creative Practices

Youths involved in interest-driven arts production expand beyond technical and critical considerations toward creative or artistic ends. In observing creative practices as they pertain to youths' interest-driven artwork, we have found that youths learn about and appreciate artistic principles by *making artistic choices* within a single modality (e.g., visual, audio, or kinesthetic), as well as by *connecting multimodal sign systems* across two or more modalities (e.g., visual and sound, visual and movement or gesture, and sound and movement) to convey an artistic idea (Peppler, 2010a/b).

As youths make artistic choices in traditional subject areas such as the visual arts, they learn about the grammar of visual design, which posits that aesthetic choices are culturally understood and put together in meaningful combinations (Kress, 1996). For instance, when making artistic choices, designers learn about, appreciate, and apply artistic principles, including choosing objects as well as their colors, size, movement, and positioning. In one youth's digital music video on Scratch (scratch.mit.edu), for example, lines on a disco dance floor converge into a single vanishing point. To create an illusion of depth, dancing robots diminish in size as they approach the horizon line. In both instances, the realism of the piece is achieved through the designer's choices within a single, visual modality. However, to further augment the meaning of the piece, the designer introduces animation and audio to the project, with flashing lights on the robots that change colors in synchronization with the flashing of an overhead disco ball, accompanied by a robotic-sounding disco track. The alignment of visual, audio, and animated effects then becomes part a unified message to the viewer, which

Participatory Competencies	Practices	Definitions
Technical Practices of Production	Coding	Practice of computer programming, particularly the use of loops, conditional statements, parallel execution, object-oriented programming, sequencing, synchronization, time triggering, real-time interaction, Boolean logic, variables, event handling, user-interface design, statements, and numerical representations (Malan, 2006; Maloney et al., 2008).
	Debugging	Practice of persisting when confronted with technical problems either prior to or during production (National Research Council, 1999).
	Repurposing	Practice of reusing earlier ideas or chunks of materials to build upon in a single or in multiple works (National Research Council, 1999). This is also a common practice particularly in the professional computer programming community.
Critical Practices of Production	Observing & Deconstructing Media	Careful observation by youth looking more closely than ordinarily at everyday objects (Hetland et al., 2007) and deconstructing both the parts of the text (at a literal level) and the meaning behind the text.
	Evaluating & Reflecting (i.e., Critique)	Practice of peers negotiating what constitutes a "good" project (Soep, 2005; Peppler, Warschauer & Diazgranados, 2010). Asking one another (even informally), given a particular artistic goal, how successfully has this goal been met?

Figure 1.2 Overview of the Participatory Competencies Needed in Interest-Driven Arts Learning

Participatory Competencies	Practices	Definitions
Critical Practices of Production (cont'd)	Referencing, Reworking & Remixing	Practice of creating original works that make knowing reference to previous works (such as games, cartoons, music, etc.). Wholly original work produced as art fall into the category of playable art and is excluded from this category (see Mitchell & Clarke, 2003). The modification of existing games, images or sounds, often to create new interactive pieces or "machinima" or non-interactive movies. Also the act of creating new genres, combining genres, or taking something from one genre and making it into something else (see Erstad et al., 2007).
Creative Practices of Production	Making Artistic Choices	Practice of learning about, appreciating, and applying artistic principles (similar to Gee, 2003), including choosing objects as well as their colors, size, movement, and on-screen positioning. This is further defined as working within a single modality to augment meaning.
	Connecting Multimodal Sign Systems	Practice of learning about, appreciating, and designing interrelations within and across multiple sign systems (images, word, and action) (Gee, 2003; Kress & van Leeuwen, 2001; Jewitt & Kress, 2003). This is further defined as working across two or more modalities to augment meaning.
Ethical Practices of Production	Crediting Ownership	Practice of referencing intellectual origins of "text" in use of media production (Perkel, 2010).
	Providing Inside Information	Practice of judiciously sharing insider codes, shortcuts, and solutions according to the cultural values in community (Fields & Kafai, 2010).
	Respectful Collaboration and Sharing	The practice of working with others in a respectful and supportive way (Freedman et al., 2013).

broadens our conceptions of multimodal literacy and what it might mean to "make meaning" across a range of modalities (Kress & Van Leeuwen, 2001; Jewitt & Kress, 2003).

Ethical Practices

Ethical practices add a fourth dimension to the critical, technical and creative interest-driven arts practices and deserve further examination, especially when individuals freely appropriate others' work in online spaces for

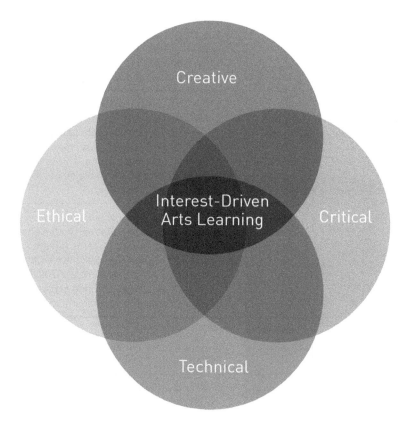

Figure 1.3 Venn Diagram of the Intersecting Core Practices of Interest-Driven Arts Learning Based on Kafai & Peppler, 2011

various purposes. Two forms of ethical practices that we have observed in youths' creative media production are *crediting ownership* and *providing inside information*. Crediting ownership consists of referencing the intellectual origins of "text" used in media productions. An example of providing inside information is the practice of judiciously sharing insider codes, shortcuts and solutions according to the cultural values in the community. Notably, what consists of cheating—whether it's revealing a solution to a puzzle or whether it's copying code—differs across contexts and what might be a perfectly permissible way of sharing information within one community might not be acceptable in another. See Figure 1.2 for a summary of these practices and the studies upon which this is built.

Building on our prior work, we conceptualize the intersection of these practices as four overlapping circles in a Venn diagram. Each of these sets of practices then aligns with the authentic and meaningful practices of experts. Any overlap of two or more circles creates an area that best describes the domain of youths' interest-driven arts practices—it's really at this intersection that youths work, crossing disciplinary boundaries and moving fluidly between these four types of practices. This conceptualization is grounded in the findings from the current study, as well as our earlier work (Peppler & Kafai, 2007a; Peppler, 2010a/b; Fields & Kafai, 2010) but also builds on the extensive work done by researchers in the other fields.

Summary

In this chapter, we have summarized the theoretical underpinnings of the report, which provide a broad foundation for understanding the review of research presented in the following chapters. In chapter 2, we turn to some of the central and compelling data driving this landscape—an exploration into the who, how and why of youths creatively using digital technology today.

HOW ARE YOUTHS CREATIVELY USING DIGITAL TECHNOLOGY?

This section brings together survey research on the availability and use of digital technologies by young people, focusing on creative uses of media. By exploring access to new digital technologies and the degree to which young people are participating in creative production and consumption, we hope to outline a fertile landscape for sowing interest-driven arts learning.

Two main studies inform our work: The first comes from the Pew Internet & American Life Project, which features a callback telephone survey of a randomly generated sample of 935 households with youths ages 12–17 years old (Lenhart & Madden, 2007).[1] Parents and children both responded to questions. The second study comes from the Kaiser Family Foundation. Its report, *Generation M²: Media in the Lives of 8- to 18-year-olds*, features a nationally representative sample of 2,002 students ages 8-18, along with a sub-sample of 702 respondents who kept a seven-day media use diary (Rideout, Foehr, & Roberts, 2010). When referring to findings from this report, we focus on teen groups wherever possible (ages 15–18).

Ownership and Use of Media

From the Kaiser report, we know that youths are spending a tremendous amount of time using media—an average of 7 hours and 38 minutes a day. Additionally, because youths are using more than one medium at a time (multi-tasking), they are actually packing 10 hours and 45 minutes worth of media content into those 7.5 hours, which represents an overall increase in media exposure by nearly 2 hours and 15 minutes daily over the past five years. Figure 2.1 shows the amount of time spent with each medium from the research by the Kaiser Family Foundation (Rideout, Foehr, & Roberts, 2010). Interestingly at the time of the Kaiser study, rhythmic video games (see chapter 3 for more on this topic) were the most popular with youths;

71 percent said they played games like Rock Band and Guitar Hero. Also of note, 45 percent of all youths reported having played Dance Dance Revolution. It's clear that video games that merge the arts earn high marks with teens. From other research we know that 85 percent of teens 15–18 years old own a cellphone, up from 56 percent in 2004 (Rideout, Foehr, & Roberts, 2010). In addition to using the device to keep in touch with friends and family, teens also report using it to access the Internet, take digital images and post content online (Kafai & Peppler, 2011; Knobel & Lankshear, 2010).

It's important to note that these trends in total media exposure are relatively consistent across demographic groups. The differences that exist tend to favor teens ages 11 and up, black and Hispanic youths, boys, and youths whose parents have less than a college degree (see Figure 2.2). Traditionally, non-dominant groups have more media exposure and thus could potentially benefit to a greater degree from efforts to get youths more involved in interest-driven pathways to arts learning.

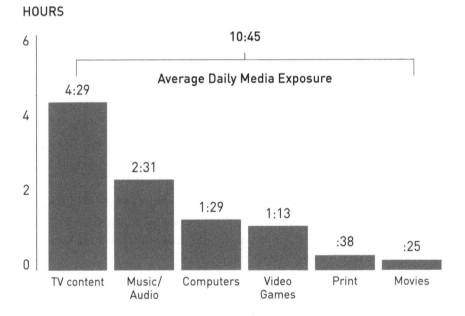

Figure 2.1 Total Media Exposure by Medium
Source: Kaiser Family Foundation (Rideout, Foehr, and Roberts, 2010)

In 2010, more than 4 out of 5 (82 percent) teens were using online social networks such as Facebook, MySpace, and Bebo (Lenhart, Purcell, Smith & Zickuhr, 2010). Teens from lower-income families are more likely to use online social networks than teens from wealthier households. This finding also supports the use of social media (as well as other media outlets) as a way of targeting traditionally marginalized youth.

The promise of youths harnessing the power of the Internet and new media platforms is dependent on their ability to develop a range of technical skills and cultural competencies, such as learning the conventions of online discourse, effective critique, and intellectual property rights. Digital technologies can be used for positive, neutral or negative ends, with a range of possible learning outcomes. What youths *do* with the tools of technology determines their efficacy. Later in this report we will discuss the importance of scaffolding instruction to help young people create and adapt media in productive ways.

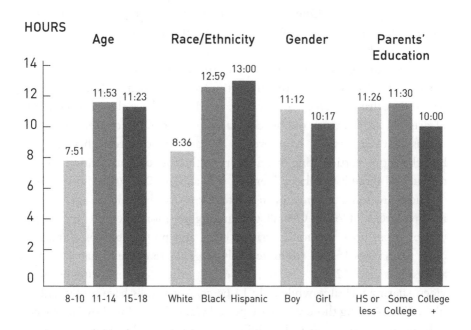

Figure 2.2 Differences in Media Exposure Broken Down by Demographics
Source: Kaiser Family Foundation (Rideout, Foehr, & Roberts, 2010)

Teens as Content Creators

Findings from the Pew Internet & American Life Project suggest that nearly two-thirds of online teens create content at some point during their media activities, such as (1) creating or working on a blog, (2) creating or working on a personal Web page, (3) creating or working on a Web page for school, a friend, or an organization, (4) sharing original content such as artwork, photos, stories, or videos online, or (5) remixing content found online into a new creation (Lenhart & Madden, 2007). According to the Pew report, 64 percent of online teens said "yes" to at least one of the forms of basic content creation listed above, up from 57 percent who were content creators in the 2004 survey (Lenhart & Madden, 2007).

Furthermore, 39 percent of online teens share their own artistic creations, such as artwork, photos, stories, or videos, up from 33 percent in 2004 (Lenhart & Madden, 2007). We also know that 27 percent of teens maintain personal websites, up from 22 percent in 2004, and that a large percentage of teens help others maintain their sites as well (proportionally more than in adult populations). One in four (26 percent) teens reported remixing[2] content they find online into their own creations, up from 19 percent in the 2004 study.

A surprising finding from the Lenhart study is that many teens use social networks to share original content, not just stay in touch with friends. The data shows that 53 percent of social network users have shared some kind of original artistic work online, compared to 22 percent of teens who do not use a social network. Moreover, in the last few years, teens have begun branching out, participating in a greater number of content-creating activities such as those listed above (Lenhart & Madden, 2007) (see Figure 2.3).

There are some differences in content creation by gender, age, family income level, and locale. Overall, girls are slightly more likely to be content creators than boys, including writing blogs and posting photos. Similarly, older teens (ages 15–17) are more likely to generate content than younger adolescents (ages 12–14). Overall, 57 percent of teens report being users of video-sharing websites, while only 14 percent of youths have posted video files online. Among those who have posted video files online, boys are twice as likely as girls to do so. Other differences summarized in Figure 2.4 sug-

gest that content creation may depend on a family's financial resources, such as accessibility of video cameras.

Although large-scale surveys tell us quite a bit about the extent of participation in online communities, they tell us very little about what youths learn in the process of production or whether their creations are of good quality. Answers to questions about the value these productions hold for the maker and the wider audience would further our understanding of interest-driven arts learning.

Conversations and Critique in Cyberspace

In the visual and performing arts, critique (Dewey, 1934; Hetland et al., 2007; Levi & Smith, 1991; Soep & Chavez, 2005) is central to learning, meaning making, and social development. Hetland et al.'s (2007) Studio Thinking Framework, for example, focuses principally on the role of critique in fostering the habits of mind promoted in the visual arts. Learning to critique teaches young people to reflect, question, explain, and evaluate what makes one representation better or more effective than another.

Digital media platforms make critique easier, more accessible, and more transparent than ever before. However, as anyone who has spent time in on-

Teen content creators do more content-creating activities than in prior years		
Number of Content-Creating Activities	2004 (n=548)	2006 (n=572)
1	45%	32%
2	27%	28%
3	16%	19%
4	10%	14%
5	2%	7%

Figure 2.3 Teen Content Creators Branch Out
Source: Pew Internet & American Life Project Survey of Parents and Teens, October–November 2006.

line forums has likely observed, comment postings and online conversations can range from outstanding to deplorable. As highlighted by new media expert Clay Shirky, a faculty member at New York University:

> The negative end of that scale is astonishingly bad—moronic rants, off-topic rambles, vitriolic attacks. ("dude just stfu nobody watches ur videos just gtfo out of you tube oh no were hurting his little feelings i feel soo bad".) It's enough to make you wish for the enforced public silence of 20th century media (2011, p. 1).

Shirky suggests that the design of online environments can support or encourage quality conversations. He points out several good examples of well-designed communities with an arts focus, including Etsy, an online marketplace and artist community that specializes in handmade items, art

Demographics of Teen Content Creators

The percentage of content creators* in each demographic category:

Sex	
Boys	45%
Girls	55%
Age	
12–14	45%
15–17	55%
Family Income	
Less than $30,000 annually	13%
$30,000 – $49,999	21%
$50,000 – $74,999	19%
$75,000 +	38%
Locale	
Urban	23%
Suburban	52%
Rural	25%

Figure 2.4 Demographics of Teen Content Creators

Source: Pew Internet & American Life Project Survey of Parents and Teens, October–November 2006. Content Creators n=572. Margin of error for teens is ± 4%.

*Content creators are defined as teens who have done at least one of the following: created or worked on a blog, created or worked on Web pages, shared original creative content, or remixed content they found online.

and supplies; Ravelry, an online hub for knitters and crocheters; and deviantART, an online home to a massively diverse and distributed audience of artists to display and sell their work, that all stand in stark contrast to YouTube and other sites that cultivate low-quality comments. The scale of the audience, the commitment of the participants to each other and to shared enterprise, and the willingness and ability of the participants to police violations are crucial components of quality online forums.

Teens report that their online postings of photos and videos frequently prompt virtual conversations with interest-driven networks of peers. Nearly 90 percent of teens who post photos online report that their audience responds at least some of the time and 37 percent say that their audience comments most of the time (Lenhart & Madden, 2007). Teens who upload videos report similar patterns of response, with 72 percent receiving comments at least sometimes and 24 percent most of the time (Lenhart & Madden, 2007). How and whether these comments can be considered productive conversations, akin to a traditional critique in the visual and performing arts, is subject to further investigation. What we know currently is presented in further detail below.

Social Network and Media-Sharing Tools

Despite their promise as learning platforms, most social networks and media-sharing tools such as Facebook and YouTube operate without clear pedagogical goals (Snickars & Vonderau, 2009). This is also true for creative sites such as Instructables.com, which lead youths and Do-It-Yourself (DIY) fans through a series of steps to develop robots, games, arts, and crafts. The broader DIY movement is comprised of individuals who do their own building, modifying, or repairing without the aid of experts or professionals. In recent years, the term DIY has moved beyond the traditional associations with home repair toward more creative ends, including a broad community of people working at the intersection of the arts and new technologies. Although activities hosted on such sites have strong ties to disciplinary learning, none of these connections are made explicit, which represents a lost opportunity for youths to gain specialist language and career preparation. Further, girls tend to be underrepresented in these spheres, making entry and community acceptance particularly difficult for novice girls to the field.

Social Learning Networks

From prior research we know that successful youth programs share key components, including access to mentors and experiential learning opportunities (EDC, 2006). With the ability to engage youths in peer mentoring and provide direct connections to content, a social learning network (as opposed to an online social network) can meet these criteria. Furthermore, a social learning network eliminates the technological and geographical barriers that make it difficult to expand place-based programs linked to schools, libraries, museums, and other after-school environments. Key benefits of a social learning network are its ability to provide youths with access to mentors who may otherwise be unavailable at a school or other sites and to support collaboration across age groups as participants work together online around common interests.

Social learning networks foster online cultures based upon idea exchange, media sharing, critique, peer mentorship, and debate. The first social learning network to achieve widespread adoption, particularly among disadvantaged middle-school youths, is *Remix Learning,* created by Nichole Pinkard, founder of the Digital Youth Network and an associate professor at DePaul University in the College of Computing and Digital Media. Remix Learning grew out of an ambitious initiative in Chicago called the Digital Youth Network, which was supported in part by the MacArthur Foundation and is now used at YOUmedia centers. Remix Learning provides an easy-to-use, customizable, cloud-based social learning network for primary and secondary education, that can be quickly and affordably implemented in schools and after-school programs. The Digital Youth Network helps hundreds of Chicago youths develop 21st-century media-literacy skills in both after-school space and in-school media arts courses. Remix Learning was developed to support mentor-student and student-student collaborations beyond the limited time provided during the school day and after-school classes.

Remix Learning allows users to post text, graphic designs, games, and videos; exchange ideas; critique work; share expertise; and debate issues. Online mentors trained and paid for through the Digital Youth Network encourage youths to post their work while also modeling behavior by posting their own original work and moderating online discussions and competitions.

The network integrates media arts courses and after-school programs, and an incentive system awards virtual currency for effective and persistent participation. The virtual currency can be exchanged for real goods, such as gift cards that can be used to buy music and expensive equipment bought by the organization or donated by foundations or other institutions. High earners receive top ranking on a leaderboard, allowing other users to track work deemed of quality by the community. A ratings system, based on rubrics, enables participants to learn specialist language and gain consistent feedback in recognizing quality work.

NUMU is another type of social learning network that operates in conjunction with the Musical Futures curriculum (www.numu.org.uk). The NUMU site resembles music-centric social networks like MySpace. It provides free spaces for schools or other youth-serving organizations to publish youths' original music, images and videos, as well as post comments and maintain an embedded blog. A primary aim of NUMU is to foster a supportive online community for youths to showcase their music, collaborate, compete, and develop their talent as performers, producers, managers or engineers in a simulated recording industry. From the NUMU homepage, youths can search for music by artist or genre, listen to tracks, review and comment on artists' work, enter into competitions, and communicate and collaborate with like-minded peers. Musical Futures youths develop skills in the process of managing their school's (or organization's) "record label" on NUMU, which may include creating music, publishing, or marketing and promoting.

Because social learning networks are relatively new and understudied spaces, we don't know whether they can or do support self-directed arts learning. For example, we don't know if youths who have already had experience working with a mentor at a community center do better than the uninitiated. In addition, we don't know whether these types of spaces support developmental pathways into arts learning or whether they are best used in conjunction with other programs. Such questions may help us refine and replicate what seem to be promising initiatives to guide young people by tying their interest in music and self-expression to learning skills needed for communication and commerce and may be transferrable to other artistic domains as well.

NOTES

1. The data summarized here refers to *all online teens,* which was 93% of the total sample. The remaining 7% of the sample was excluded from further analyses within the report.

2. Remixing involves the combination of "semiotic resources into new digital or multimodal texts." Formal spaces have mistakenly character-ized remixing as plagiarism. By contrast, informal learning spaces have embraced this trend—i.e., creating a "culture of appropriation" as a method of making something one's own (Erstad, Gilye, & de Lange, 2007; Perkel, 2010).

3

THE NEW DIGITAL ARTS:
FORMS, TOOLS, AND PRACTICES

When the May 2009 cover of *The New Yorker* featured Jorge Columbo's "Hot Dog Stand," a design he created on his iPhone using a $5 application called *Brushes*, it focused national attention on the way mobile devices are rapidly changing how people create and engage in the arts. The *Brushes* app is just one example of digital and mobile tools, many of them free, which inconspicuously blend artistic activities into everyday lives. From the visual and performing arts to gaming technologies, artists are using and adapting tools for creative expression and communication.

Older art forms have not only migrated into the digital realm, but they are also radically changing and expanding in response to new tools available for production. For example, tools enable novices to compose original music without using traditional instruments or having access to recording studios, as well as enable painters to mix virtual paint without paying for materials or gaining prior experience in art class. Although some people may fear that youths will abandon respected historical methods in favor of new digital media production practices, we argue quite the opposite. New technologies—whether offering lower-cost/higher-efficiency reincarnations of earlier media or creating forms that were not possible with analog tools—are designed to expand audience participation and appreciation of prior traditions.

To a certain extent, the evolution of every art form is inevitable whenever new media is introduced. Conversely, not every form of new technology ruptures paradigms; some technology actually reinvigorates interest in traditional methods by reducing barriers to participation.

In this chapter, we showcase ways that youths are exploring a range of interest-driven arts learning opportunities. Although our list is not comprehensive (and the divisions among the various art forms are certainly contentious and not recognized by most youths doing interdisciplinary work), we have tried to cover a wide variety of disciplines and grassroots movements in our review.

We separate our findings into two larger categories of artistic production: old forms that are re-envisioned with the help of new tools, software, hardware, and online communities; and new art forms unique to the medium of the computer, including video game design, media arts (the blurring of computation, media, and Information Communication Technologies), and Do-It-Yourself (DIY) fusions of sculpture, robotics and crafts. The latter category will be explored in Chapter 4.

Old Forms Re-envisioned

In the digital realm, traditional divisions between high and low art often blur. Youths draw on whatever tools and inspiration are available to make and share art, and they see very few disciplinary boundaries to their explorations. Although we have organized this review according to recognized genres of art, most of the art being produced today defies easy categorization and could be described as a remix of existing media into new production practices.

Visual Arts

Nowhere are youths combining old and new media and high- and low-tech work more so than in the visual arts. This shift has occurred in part because teens can easily capture their original artwork and post it online, with or without digitally enhancing or manipulating the images. Popular sites of this practice include deviantArt—which boasts more than 12 million members and 100 million submissions as of fall 2012—and social network spaces such as Facebook and MySpace. Many online spaces for art sharing enable contributors to include information about their original pieces. The comment sections of some websites allow for reflection and meaning making.

In addition to visual art tools such as Painter7 and iPad/iPhone/Android apps, the Nintendo DS Art Academy enables players to use traditional tools in a virtual environment, learning the basics of drawing, mixing colors, and shading. Browser-based tools that allow for image production and manipulation, such as those found at Aviary.com, are often available without any licensing fees. Offering many of the same features as costly professional tools, Aviary has photo image-editing capabilities (similar to Photoshop) but adds other tools for multimedia productions, including screen capturing, vector editing (useful in making logos or other graphic designs), typography, special effects, music composing, and audio editing. This powerful, free suite of online creation tools lets people create digital media without the often-prohibitive barrier of obtaining funding for projects. Within the Aviary community, artists can combine and reference sources that are used to create images, movies, or audio to share with the public.

In the following section, we summarize three broader trends in the visual arts, including the creation and adaptation of comics, manga, and photography. Highly popular in youths' informal learning communities and under-represented in the traditional arts education curriculum, these genres suggest opportunities to integrate the two spheres.

Comics and Manga

Comics are part of a 120-plus-year-old medium that includes graphic novels, comic books, individual images, and animation. Historically, comics have been stigmatized as a "lowbrow medium" among scholars, parents and educators (Wright, 2006). Although a popular form of production in youth culture, comics have not been welcome in the traditional visual arts curriculum. Consequently, many youths share their work through online communities or contribute to "zines," self-published volumes that are mailed directly to their readers (Congdon & Blandy, 2003).

Similarly, manga—Japanese for "amusing drawings"—refers to collections of printed comics found in graphic-novel format. The integrative storytelling style of manga relies on highly contextual cues: facial expressions, tone of voice, and grunts (Ito, 2005). It is not unusual for subjects of the comics to be drawn breaking out of their rectangular frames, an artistic technique

intended to capture certain feelings and emotions (Adams, 1999). Moreover, the dialogue and the visuals in manga are not just expressed through the written words, drawn characters, and landscapes. Readers in Japan must also negotiate a variety of fonts and script styles, dialogue may be printed in kanji (Chinese characters), alternate between the two Japanese character families of hiragana and katakana, or borrow from English (Allen & Ingulsrud, 2003). Manga and comic designers create their work freehand on visual art platforms, which are either shared digitally or exhibited at conventions dedicated to the art form: Anime central (www.acen.org), Alternative Press Expo (www.comic-con.org/ape), Fanime Con (www.fanime.com), Wonder Con (www.comic-con.org/wc) and the longstanding Comic-Con (www.comic-con.org, the largest comic convention in the world). All offer opportunities for amateur comic and manga artists to come together and, in many cases, sell their work. Conversely, many new technologies are dedicated exclusively to aiding designers in creating manga-style illustrations (such as Web tools on www.toondoo.com and www.pixton.com, or mobile apps such as ComicBook! by 3DTOPO), while several widely available image manipulation platforms (such as Photoshop and iPhoto) include built-in filters to apply the look and feel of comics to digital photos.

Given the record-setting sales of manga across the United States, the proliferation of online and physical communities dedicated to the creation and sharing of comic and manga artwork, and the rate in which manga comics are checked out at public libraries (Carey, Reid & Kawasaki, 2005; Schwartz & Rubinstein-Ávila, 2006[1]), some consider it discouraging that many educators have been reluctant to probe this genre for possible sources of meaning making. Recent research points to the ways that manga comics encourage critical, multimodal reading skills (Schwartz & Rubinstein-Ávila, 2006). Gail Boldt (2009) has suggested that researchers investigate manga's potential to engage students in the traditional arts curriculum while exploring a new canon of visual imagery.

Digital Photography

The widespread availability and affordability of new digital cameras is rapidly lowering the barriers to enter the field of photography, as well as changing the landscape of this art form (Ito et al., 2010). Research has focused on

the changing cultural values of the medium from professional production to amateur production, which has an impact on the aesthetics and genres in photography today (Jackson, 2009). Making and posting digital photographs is one of the primary pathways into digital art making and participation in the out-of-school hours. Further, these advancements have kept some older technologies from becoming obsolete. Polaroid pictures, for example, are often scanned and manipulated using popular software such as the Adobe Photoshop Series, Adobe Elements, iPhoto, and freeware such as Gimp and Fotoflexer.

In addition to sharing photos through social network sites, youths frequently join Flickr, Photo.net, Fotki, Myshutterspace, Eyefetch, and other online communities. Flickr allows for sub-communities to form according to subject, genres and level of expertise, to name just a few categories. Flickr also enables users to categorize digital images, ranging from textures created in Photoshop to photographs made by members, which are not only shared with but also remixed by the larger community.

Teen behavior indicates a preference for photography as a means of social communication, most notably through exchanging images as a peer group message system (Liechti & Ichikawa, 1999). Photo-sharing (posting and tagging photos in online communities) can bring together sub-communities of artists into physical gatherings, such as the Graffiti Jam for artists interested in documenting graffiti (Merchant, 2010). This type of self-organizing across virtual and physical spaces draws in new members (non-graffiti artists, in this case) who share their passion for this medium as well as discuss technical tools and other topics important to digital photography. Guy Merchant, a British professor of literacy in education, identifies five distinct ways that photo-sharing contributes to learning, including (2010, p. 93):

- *Learning through seeing.* Sharing visual images can lead to a process of learning that Merchant describes as "attentive noticing." By becoming part of a specialist or expert community, the learner is able to build on an initial interest in order to gain more knowledge about a topic.
- *Learning through reflection.* In this process, learners use an image or a sequence of images to frame an object or event. Reflection involves

looking again or looking more closely, and visual images are especially useful for this process.

- *Learning about image.* Developing an understanding of visual culture, image composition, and effect enables learners to appreciate the technical skills of photographers. This process also involves looking at image and context, seeing how techniques such as cropping and manipulation change the way we read the visual.
- *Learning about multimodality.* Visual images, mixed with sounds and music, spoken language, and the written work, create meaning together.
- *Learning about Web 2.0.* Photo-sharing sites such as Flickr incorporate key social networking features. The wide range of social interactions that are supported, the practices of tagging and aggregation, as well as features such as personalization and inter-operability, make photo-sharing a study in Web 2.0 orientation.

These areas cover a wide range of educational topics and contexts important to image production, sharing, and distribution and point to some ways in which youths can informally learn about photography within online communities through tutorials, peer-to-peer assistance, expert mentorship, and self-study.

Digital technologies have opened new genres of photography as well, including rendering photographs first within the virtual environment of video games and then snapping them using screen capture software. This practice can be considered a form of fine art photography because of the way light, composition, and other effects are taken into consideration. Another trend involves blending photography with other media, such as pencil drawings. Lastly, much of teen photography has a highly surrealistic quality, such as beginning with a digital image of a frog or other real life form, and then editing and adding features to create fictional landscapes.

Photography as an art form can also be deeply rooted in a social justice agenda that empowers non-dominant groups to tell their own stories and change their communities. For example, Caroline Wang of the University of Michigan and Ann Burris, Program Officer for Women's Health at the Ford Foundation, developed Photovoice (www.photovoice.org), a partici-

patory research methodology that combines photography with social action (1994). Participants are trained to use a camera as a documentary tool that captures and expresses the experiences of their environment.

The relatively low barriers to enter the field and the proliferation of communities like Flickr enable youths to tap into a range of learning opportunities and creative expression, making photography one of the most democratic art forms. Young people can easily and inexpensively post souvenir images, daily life images, networked images (connecting a visual to text or other media), and artistic images (Potter, 2010). Additionally, digital photography makes a distinctive contribution to the development and expression of visual literacy. Notably, youths seem to enjoy the immediacy of trial and error without fearing that they will lose or spoil parts of their work (Loveless, 1999).

Dance

Although researchers have largely ignored the impact that technology has had in the field of dance, several noticeable developments have emerged in recent years. In this section, we summarize efforts to document informal dance (in nightclubs and the streets of South Los Angeles) as well as developments in commercial video games, costume design, and other interactive labs that have expanded dance in new directions.

Members of dance communities, similar to those in any arts community, have created online spaces dedicated to sharing their versions of popular dances on YouTube, BoogieZone, dancejam.com, dance.net, and MTV. The Internet adds a new dimension to the performer-fan relationship. For example, Beyonce's original dance video for the title "Single Ladies" generated several hundred variations posted by fans. Other music artists, such as Soulja Boy, leverage the Web to encourage fans to learn, perform, and share variations of their music and dance videos.

Perhaps one of the most well-known mergers of dance and new technologies comes from commercial video games. As mentioned previously, nearly 50 percent of young Americans have played Dance Dance Revolution (DDR), which creates a "dance platform" or stage and uses pressure sensors to detect movements. Players are judged by how well they time their

dance to the patterns, and they can choose more music if they receive a passing score. Although the game is immensely popular both in homes and in arcades, it has limited dance moves and space—good for coordination but inadequate for considering performance. That said, exceptional players have worked within the constraints of the game to perform expressive moves. Many notable YouTube performances capture the degree of artistry within the community (Smith, 2004).

The Xbox Kinect system, which uses a video camera (no game controllers or devices needed) to record and project the player/dancer on a screen and assess the quality of the dance movement, seems to take the connection between dance and digital media to the next level. Games created for the system incorporate more than 300 unique dance moves, introduce dance-related vocabulary, and provide performance opportunities for up to three youths at a time. Early observations indicate that the game mimics the process inherent in dance auditions, where the instructor or choreographer teaches a combination to the group and then asks each dancer to perform with little rehearsal.

One of the major benefits of these new video games is the possibility of introducing a common set of dance vocabulary to young people without the expense of private or group lessons. Additionally, dance and popular culture have renewed interest in traditional forms as well as expanded genres of dance. For example, "Dancing with the Stars" and other popular television shows have sparked an interest in ballroom dancing and other types of dance across age groups and geographic regions (Kerns, 2009). Through this example, we can see how interest-driven arts learning can be tightly coupled with popular culture.

There are also several other ways that artists, engineers, and educators have combined dance, choreography, sound, and light. For example, new technologies are being used to record dance through sensors placed strategically all over the body to track and record movement. This technology is so widely used now that professional dancers are hired for film productions, such as Nickelodeon's *The Backyardigans* or New Line Cinema's *The Two Towers* (from the Lord of the Rings trilogy), so that their movements can be more realistically simulated in the animation environment. Pioneers

in this field, such as David Birchfield, have introduced what they refer to as SMALLab (Situated Multimedia Arts Learning Lab) learning. Within a 3D space, multiple strategically placed cameras are arranged to respond to the movement and gesture of dancers holding a baton. In turn, the dancers can control music interactively through their gestures. Similarly, Kylie Peppler and an interdisciplinary team of colleagues have used commercial technologies like the LilyPad Arduino to create interactive dance costumes for use on stage by dancers (Lindsay, 2013). The dancers' gestures transmit signals through their costumes. The signals are relayed to a laptop computer offstage and then played through the auditorium's sound system. This array of technologies points to exciting advancements in the world of dance and the development of sophisticated interest-driven communities around dance.

Digital Music

The widespread availability of inexpensive recording hardware and software (e.g., Aviary, Audacity, and Digidesign's Pro Tools), coupled with the expanding opportunities for amateurs to distribute and share their work online, has caused tremendous shifts in the music industry (Graham, 2009). In 2009, digital sales surpassed physical CD sales (Arango, 2008). Because musicians can now sell their work directly through online marketplaces such as iTunes, they do not need to wait for major record label deals and difficult-to-obtain album contracts. Some young artists have started their own DIY record labels and/or marketing themselves primarily using free services, such as YouTube and other social media platforms. Instead of following the lead of professional artists, young artists are redefining how musicians share and distribute their work in the 21st-century digital marketplace.

Further blurring the lines that once divided artist, record company and distributor, music technology has made it easier for novice musicians to produce professional-sounding work. Apple's Logic and GarageBand, Sony's ACID and Sound Forge, Cakewalk Sonar, ReCycle, FL Studio, Propellerhead's Reason and Ableton Live are all prominent examples of programs that enable musicians to create original compositions featuring realistic virtual instruments, radio-ready beats, and audio engineering effects—while using little more than an electronic keyboard and a laptop. Youths who have

never learned to play an instrument can create entire compositions by dragging and dropping various arrangements of prerecorded "loops"—royalty-free segments of drum patterns, musical gestures, and chord progressions. Although detractors could argue that music built on others' loops is not wholly original, the use of pre-recorded loops (or "samples" from other artists' work) is arguably an authentic practice of professional composing and producing as evidenced by its pervasive use in genres such as hip-hop, electronica and rap. Many companies are dedicated to the sale of loops and sample music libraries. With the right tools, a music hobbyist can create something in 15 minutes that used to cost people $1,500/hour to produce with live musicians in a studio. Further, a flood of new mobile apps, such as Beatwave, Sonorasaurus, Pattern Music, and Looptastic, is expanding the opportunities for music creation.

As these programs redefine what it means to be a 21st-century composer, new technologies are expanding the channels through which people perform and learn about music. The music education community has long lamented that many youths fail to connect the repertoire, instruments, and skills embodied in informal music activities (e.g., rock music, garage bands, songwriting and the cultural capital that comes with those activities) to formal music education. Music education that youths learn in garages and online environments is quite different from what their peers learn in high-school bands and orchestras (Green, 2002).

In the past decade, "rhythmic video games" have dominated this informal music space for teens, according to demographic sales and usage statistics (Quillen, 2008). Rhythmic video games—the hugely successful Guitar Hero, DJ Hero and Rock Band franchises by Harmonix are especially salient examples—are music-themed action games that require players to press buttons in a sequence dictated on the screen in time to a soundtrack. Doing so causes the player's avatar to dance or to play a virtual instrument correctly. A 2010 study demonstrated that extended play in Rock Band positively correlated with the assessment results of youths' traditional music abilities, providing evidence that youths playing rhythmic video games see a connection between the two ways of notating music (Peppler et al., 2010). Although such correlations do not prove a causal shift, they suggest some

interesting interpretations: First, it's possible that extended Rock Band play can positively impact the traditional music competencies of novices. Second, youths who already have traditional music backgrounds may be more likely to persist in rhythmic video games. This interpretation suggests that youths can make connections from one internalized sign system (in this case, traditional notation) to another (like Rock Band musical notation). Although there are obvious differences between learning to play a guitar and learning to use a peripheral device shaped like a guitar, Brown University ethnomusicologist Kiri Miller argues that performing a song in a game environment such as Guitar Hero or Rock Band is an authentic music performance (2009).

Online Web communities for digital music composition and performance have given users a place to share, critique, and collaborate with others. New online communities for sharing music include MacJams, iCompositions, Circuit Benders, General Guitar Gadgets, Create Digital Music, Facebook/MySpace and Soundcloud. Such communities represent a major shift in how music is consumed and created—from a solitary act of music composing via paper and pencil to a worldwide collaborative and creative enterprise.

Most of these technologies have not come about because educators or researchers have called for them but because users have demanded them in one way or another. Spending years practicing a musical instrument may be important to gaining the instrumental facility valued by schools of music, but it is not always something young people have the time, money or inclination to do. New technologies allow the novice to create an identity, whether it is in a video game (Gee, 2003; Miller, 2009), a garage (Green, 2002), or a bedroom (North & Hargreaves, 1999) and then further shape that identity by interacting with the tools and the community (Gauntlett, 2007).

The underlying story behind much of the market demand for these tools is that children (and adults) know more about music than they realize (Bamberger, 1991). Jeanne Bamberger, an emeritus professor at the Massachusetts Institute of Technology and developer of the software Impromptu, has shown through her research that both novice and expert musicians talk

about music in much the same ways; that is, music is perceived in meaningful "chunks" rather than discrete properties (e.g., "notes"). So, while real or perceived barriers often prevent people from continuing formal music education after a certain age (Torff, 2002; Asmus, 1986), new technologies are opening doors for young musicians and composers.

Drama

Traditional drama takes on many new forms in digital media, including film, radio, machinima, and animation. Across the spectrum, young people are assuming multiple roles as actors, script writers, directors, producers, set designers, lighting specialists, and camera crew members—positions that are possible because of the lower costs and increased capabilities of today's tools. Common tools include editing software such as iMovie; recording software such as Screenium, iChat, and iDVD; video cameras; cellphones; and computers; as well as Web-based tools such as Xtranormal, GoAnimate, Animasher, Toondoo, and Masher. Some teens are using video game consoles like the PS3, Xbox, and Wii for their productions, particularly of machinima (described in further depth below). Media education studies have slowly been acknowledging the importance of video to identity development and the broader media education curriculum (Buckingham, 2003; Halverson, 2010; Goodman, 2003; Fisherkeller, 2002). We have chosen to focus on four specific trends that align youths' interests in media with drama and theater at their core.

Film, Video, and YouTube

Video is one of the primary modes of content production for today's youths (Lenhart & Madden, 2007) and is well aligned with drama and theater activities. With smartphones (which enable instant posting of media directly to sharing sites) on the rise, this form of participation will likely accelerate. YouTube, which started as an interpersonal video sharing service and has quickly grown into the world's leading video community on the Internet, is used by amateur and industry professionals alike to reach broad audiences and contribute to social discourse (Snickars & Vonderau, 2009; Gauntlett, 2011). Although YouTube isn't designed to promote a particular

form of creativity or connect users to a niche community, many youth engage in drama and theater practices in the process of producing their video content. Most compellingly, people create YouTube videos because they want to, not because someone wishes to herd them into film production.

This type of filmmaking crosses into many disciplines, such as literacy, communication, digital media, critical thinking, creativity, storytelling, and visual poetry. An example of an online community that supports teen-centric filmmaking is Reelworks (http://reelworks.org/), which allows participants to tell their personal stories and then promote them on the site. Films are available for viewing and purchasing, and each film has a snippet of information about the film and its creator.

Podcasting and Digital Radio

Older forms of media such as radio are still dominant but are now being digitally created and distributed in online communities. Notable examples include podcasts, the Internet's form of broadcasting, and digital radio stations. Leah Lievrouw is one of the preeminent scholars studying the relationships among media, new technologies and social change (2003/2008/2011). Much of her work investigates the various forms of oppositional and activist new media that enable people to bypass and, at times, intervene in the mainstream media. Youths today are using podcasting and digital radio to make their voices and viewpoints heard, often attracting a wide audience.

One of the most notable organizations in this landscape is Youth Radio (Soep and Chavez, 2005), which works with youths to tell, edit, and broadcast their stories through National Public Radio and other online outlets. Youth Radio's media education, broadcast journalism, technical training and production activities provide unique opportunities in social, professional and leadership development for young people, ages 14–24. As youths connect to their communities through media literacy and professional development, they become active partners in civic engagement. They also assume identities as disc jockeys and create their own Web pages, stations, and shows. Over time, young people learn to build an audience for their work by using their social networks and bringing in peers as guest artists.

The shows they create have investigative news features and compelling personal narratives that air nationally and touch the lives of millions of listeners each month. Youth Radio incorporates an apprenticeship model that assists young producers until they gain the skills to work on their own.

This type of interest-driven arts learning outlet for teens is important because of the ways in which young people learn a set of skills and gain a community that supports their work. At a time when much of the production and programming aimed at teens lasts only a few weeks, Youth Radio offers sustained opportunities for arts learning. The age range is also broader than most programming, suggesting ways that efforts aimed at getting teens involved in interest-driven arts learning could also appeal to young adults in the 18–24 age range who might be struggling with whether and how to go to college.

Animation

Formal education and many online communities still support traditional forms of animation storytelling (flipbook and stop-motion including Legos, clay, toys, paper cutouts, and so forth), which are still quite popular with youths and are based on the early days of cinema. Such work harkens back to Georges Méliès's film trick techniques in the early 1900s and Eadweard Muybridge's sequential horse gait movement stills. In their book, *The Animate! Book: Rethinking Animation,* Benjamin Cook and Gary Thomas argue for a more experimental form of animation, one that places animation within contemporary art practice as a real art form (Bridge, 2006), which can be captured and manipulated using digital technology.

At the same time, digital technology is changing the way users are engaging in animation (Chong, 2008), both in terms of access and technique. In addition to computers, animation can now be created on handheld digital devices, such as iPad's Animation Desk, the iPhone's Animation Creator, and the Nintendo DS Inchworm Animation. Popular techniques in animation include stop-motion animation, machinima, and Flash animation. Technologies and software used in/by the community include digital cameras, webcams, Anasazi Stop Motion Animator, Adobe Flash software, Bricksmith, iStopmotion, and Dragon Stop Motion.

Some animators are experimenting by integrating digital technologies. For example, producers have hacked the Xbox Kinect system to capture 3D images for animation programs (Madhav, 2011). The process is similar to technology used in the film *The Polar Express,* where body and facial movements were captured digitally from sensors. Digital animation through puppetry is another area where experimentation is occurring. Producers use Arduino technology to animate puppets on a digital screen (Kirschner, 2011) or to create digital puppetry games and simulations to be acted out (Peppler et al., 2010).

Educational designers and researchers Karen Brennan, Andres Monroy-Hernandez and Mitchel Resnick (2010) observed teen animators using Scratch, a visual programming language that allows for easy animation by snapping together blocks of code that direct the actions of onscreen objects. Their study revealed that teens were able to interact with the Scratch community to develop technical expertise, push their thinking, and reflect on their contributions to interactive media.

Machinima

A medium in which artists create stories using video games, animations, or cartoons, machinima changes the essence of the game or film by re-purposing original content (Luckman & Potanin, 2010). Most creators of machinima see this art form as an inexpensive and efficient form of film-making, in which the gaming element is merely a way to direct characters, leverage pre-existing settings and create new storylines.

Machinima was originally created from first-person shooter games like Doom and Quake, where players would video-capture their onscreen avatars moving throughout the virtual space—dancing, making gestures, encountering monsters or engaging in combat. Later they edit this raw footage in another program, dub their voices over the action, and create new plotlines and character sketches. In many cases, machinima films are narrated in real-time and are often created by multiple players using headsets to provide live voice-over audio. Some machinima productions feature stunts or other portrayals of game play. Popular genres include dance videos, comedy, and drama. Some film festivals accept machinima entries, and several

game companies, such as Epic Games, Blizzard Entertainment and Jagex, sponsor machinima competitions.

Creative Writing

Creative writing sits on the border of visual and performing arts, as digital images, film, and performance become increasingly integrated into the art form. Popular genres of creative writing today include digital poetry, spoken word, and fan fiction.

FanFiction

FanFiction or FanFic is a genre of stories created by amateurs and based on narratives from popular media texts, including books, television shows and movies. It is a practice that preceded the Internet and constitutes a major aspect of fan cultures in general (Jenkins, 1992), but websites have greatly increased the reach and exposure of FanFic.

The most popular sources for FanFic include the Harry Potter, Star Trek, and Twilight series, Japanese anime and manga (both animated cartoons and comics), as well as popular video games such as The Sims (Gee & Hayes, 2009). FanFic varies in styles and forms and includes humor/comic, tragic, fantastic, mature, and romance (Chandler-Olcott & Mahar, 2003a).

FanFiction has a strong relationship to other fan art in the form of drawings, anime music videos and fan website design ("shrines") (Chandler-Olcott & Mahar, 2003a). Teens who write FanFiction participate to have fun, explore imagination, avoid boredom and solidify social relationships (Chandler-Olcott & Mahar, 2003b).

Scholars have focused on FanFic as a form of fan culture (Jenkins, 1992), as an emergent practice promoting literacy in teens (Black, 2008), as part of a larger conversation about expanding notions of traditional literacy (Chandler-Olcott & Mahar, 2003a), and from a legal perspective regarding fair use (Nolan, 2005; Chander & Sunder, 2007; Lewis et al., 2009; Schwabach, 2008).

Digital Poetry & Spoken Word

There are many types of digital poetry, such as hypertext, kinetic poetry, computer-generated animation, digital visual poetry, interactive poetry, code poetry, holographic poetry (holopoetry), and experimental video.

Some digital poetry synthesizes art and multimedia components, such as sound, and some involve collaboration through wikis, blogs, and listservs. Many online poetry communities sponsor contests, although almost none specifically target teens except Re:Verse Poetry Zine and DarkPoetry.com. Some online poetry has been published (see *Poetry Daily: 366 Poems from the World's Most Popular Poetry Website*), highlighting a broader theme of the relationship between informal arts participation and professional production and recognition practices.

Research in the area of poetry and digital media has largely focused on the changing nature of poetry to integrate multimodality (Zervos, 2007), a return to its historical roots in performance, an increase in access (Richey & Kratzert, 2006), and an upending of traditional guidelines and categories in the world of poetry by infusing recordings, short animations, interactive text, and other features of new media into traditional poetry (Rasula, 2009). There seems to be little or no scholarship on teen participation in poetry communities online. What we do know often comes to us from participant observations and action research that uses spoken word as a bridge to traditional texts like canonical poetry (Morrell, 2002).

Spoken word, live poetry slams, and other similar competitions are common art forms in youth culture, particularly in urban centers. Many of these performances are video-recorded and shared with the larger community (see, for example, the Chicago YOUMedia teen winner at http://youmediachicago.org/featured_contents/99, as well as other scholarly work [Hull and Schultz, 2002]), which are testimonials to the powerful art being produced by teens in this genre.

Summary

In short, the field of interest-driven arts learning represents a resurgence of traditional visual and performing art forms through new technology enhancements. Contrary to popular belief, youths are making a renewed commitment to the arts that is invigorated by new variations of traditional art forms. Deeply rooted in youth culture, these new art forms make it possible for young people to share their work, receive immediate feedback from peer groups, and gain access to experts who can help them hone their craft.

NEW MEDIA ARTS, THE DO-IT-YOURSELF MOVEMENT, AND THE IMPORTANCE OF MAKING

This chapter conceptualizes the role that new media can play in arts learning. First, we explore how professional artists are using digital media to create new art forms and suggest how these tools can involve youths in similar processes. Second, we look at computer programming, which has become one of the fundamental skills of learning art in a digital world (Peppler, 2010b), and some of the ways youths are already using computer programming in their interest-driven artwork, video game design, and in the ever-expanding Do-It-Yourself (DIY) movement. We conclude by considering broader questions, including what youths may gain from experiences in making, more generally.

New Media Arts

Art that makes use of electronic equipment, computation, and new communication technologies comprises the emergent field of "media arts" (also called digital arts or new media). Although the field is still being defined, it can be distinguished from traditional disciplines such as visual art, music, dance, and theater, yet also includes some overlap that arts educators may recognize, such as visual arts, animation, film, and, electronic music. For example, media arts share concepts and terminology with a range of other fields, including the sciences (gravity, mass, and acceleration), animation (tweening and motion paths), visual arts (color, perspective, and shape), and

film (vocal intonation, visual style, and direction). In this sense, media arts could be described as a "meta-medium" that spans many different types of artistic practices. Central to most work in new media is the role that computer programming plays, which we refer to as "creative coding" elsewhere in this report, giving artists a fuller range of control over the artwork.

Creative Coding

Although a large number of programming tools have been around since the inception of the computer, few have traditionally appealed to visual artists, in part because prior languages were difficult for novices to learn. As a result, media artists have created new tools that reshape the fundamentals of artistic practices to the extent that computer programming has become a crucial skill for working in the field. Media artists Casey Reas and Ben Fry assert that "software is the medium that controls this flow of bits traversing the air and surface of our planet. Understanding software and its impact on culture is a basis for understanding and contributing to contemporary society" (2006 p. 526). However, learning to computer program—or code—in the arts differs substantially from learning to computer program in the context of a computer science course. Within the arts, the emphasis is placed on what we might call expressive or "creative coding," which may not be an efficient or elegant programming solution but rather produces a particular result or effect toward artistic ends.

An important consideration for creative coding is that youths don't need to gain proficiency before they can produce media art. Although popular conceptions of computer programming envision users typing lines of equations and formulae onto an empty screen, numerous visual programming languages scaffold the programming environment with graphic "drag and drop" interfaces. Several shortcut tools enable youths and adults alike to use programming concepts such as loops, conditionals, data types, and numerical representations with ease. One popular tool is Processing, which was created by Casey Reas and Ben Fry (2006). This open-source programming language for creating images, animation, and interactions is used by youths, artists, designers, researchers, and hobbyists. Other popular programming environments, such as Arduino or Modkit, enable users to create programs

that will facilitate interaction with an external object, such as a robot or a machine. These tools target professional artists and Do-It-Yourself (DIY) enthusiasts, but other tools, such as Scratch (Resnick et al. 2009), Alice (Adams, 2007) and LEGO Mindstorms (Papert, 1980) have been widely used by younger artists, as well.

Scratch (Resnick et al. 2009; Peppler, 2010a/2010b) represents a particularly engaging medium for teens due to its media-rich capabilities and novice-friendly design. It is immensely popular in both school and informal settings. By the middle of 2012, it had been translated into more than 50 languages, and nearly three million Scratch projects had been uploaded to the www.scratch.mit.edu community. Scratch uses a building-block command structure, which eliminates the need to memorize bits of code to program. Users can choose from several pages of commands and drag the features to a central screen to control objects, characters, or graphic images created in the program's paint editor or imported from a computer file. Designers can also incorporate existing sound or image files, as well as integrate other input/output devices into new projects. Teens have used Scratch to create projects ranging from art objects to animated stories, which can run uninterrupted in their entirety (like a music video) or require the user to interact with the pieces through keystrokes (as in a video game).

The familiar building blocks of Scratch are now being incorporated into a variety of new environments, including Modkit (http://www.modk.it), a new program that controls Arduino microprocessor computers used in robotics; Stencyl (http://www.stencyl.com), a new game design software; and Google's new App Inventor for Android. By contrast, many of the other widely available tools for image creation, animation, and game design advertise that they don't require programming skills but tend to only allow creators a limited number of choices. This "platform approach" to media art making, popular in tools such as Photoshop, can unnecessarily restrict youths and can cause a great deal of confusion between software updates. Our interest is in advocating software that allows for a great deal of flexibility across all modes.

Although some critics fear that these tools will be inaccessible to all but top-level youths and impossible to learn in the unstructured, informal hours

outside of school, we have found that the new technology accommodates varied ability levels (Peppler & Kafai 2006; 2007a; 2007c), including youths who are struggling to read, write, and identify printed letters. Across the spectrum, young artists use computer programming for expressive aims, demonstrating that computation can be a tool for artists and not just computer science experts.

Video Game Design

Although creative coding can be used to create a wide array of genres, including animations, digital stories, music, simulations, and interactive art, one of the most well-defined uses of creative code is to create video games. Immensely popular with today's youth, game design is a relatively recent addition to the field of arts education. The academic community in the 1980s and 1990s concentrated on the psychological impact of game play by discussing gender differences in spatial reasoning (Loftus & Loftus, 1980) or the perception of violence (Provenzo, 1991), with the occasional studies evaluating educational applications of game design. (For a more extensive review, see Egenfeldt-Nielsen, 2007.) Designers at game companies, not players at home, were seen as the producers of content and mechanics. Researchers in media studies perceived viewers mainly as consumers of media and did not see critical inquiry reflected in production work (Jenkins, 1992). Education researchers, meanwhile, questioned the general learning value of games and focused mainly on motivational benefits (Lepper & Malone, 1987). Game companies saw the production of game content as their domain.

Idit Harel (1991) was one of the first to study how game design could provide a long-term, meaningful, and integrated context for students to learn programming and mathematics (Palumbo, 1990). In one of the first empirical studies of game design in schools, Yasmin Kafai (1995) invited a class of 16 elementary students, ages 10–11, to design computer games that would teach younger students in their school about fractions. For six months, students designed their own games using Logo programming and created packaging and advertisements. The designers met about once a month with the younger students who provided feedback on various aspects of their games (see also Kafai, 1998). The observed gender differences

in the narrative, components, aesthetics, and mechanics of the games have received the most attention (Kafai, 1996a; 1998), likely because these findings aligned well with then-popular discourse about gender differences in interest and performance in technology and games (e.g., Cassell & Jenkins, 1998). Much less attention was given to the equally important aspects of design practice, collaborative planning, and public critique that contributed to students' understanding (Kafai, 1996b) and resonates with current approaches to game designs for learning. As demonstrated in current research, when youths design their own games, they can learn about game genres (interactive narratives, fighting games, mazes, and so on), animation, perspective, motion paths, audio design, computer programming, and interaction design (human-to-human interaction design) (Peppler & Kafai, 2010). Popular online communities for sharing such original game designs include Scratch, Atmosphir, Gamestar Mechanic, and Games for Change.

More recently, David Buckingham and Andrew Burn (2007) have suggested using the term gaming "literacy" to reflect the representation of multimodal texts that integrate sound, music, graphics, writing, and more. Katie Salen's (2008) notion of gaming "literacies" reflects the multiple professional practices involved, including expertise "in graphic design (visual design, interface design, information architecture), product design (input and output devices), programming, animation, interactive design (human-computer interaction), writing, and audio design, as well as content areas specific to a game" (p. 318). For these researchers, the design of new games is not the only way to become literate in the field; writing reviews, modifying game components, and designing games are equally important. In addition, James Gee and Elizabeth Hayes (2009) believe that remixing existing games leads to the development of marketable skills and shifts the focus of game culture from killing, fighting, and other violent actions to creating and designing.

Commercial industries also have created games to teach youths to design games or other art forms. Will Wright characterizes this approach to game design within games as "dream machines" (2006, p. 1). Well-known examples include E-Line Media and the Institute of Play's Gamestar Mechanic, which allows youth to learn about the fundamentals of game design

by fixing games and designing entirely new games; also, Sony PlayStation's Little Big Planet, which allows the learner to build new levels and expand the environment, collect varied tools and objects to make a mark on the game world, and play games and puzzles designed by others in the community. Other approaches use games to provide a meaningful context to learn about the arts, including the visual arts in ArtAcademy for the Nintendo DSi platform as well as 3D modeling and elements of architecture in Quest Atlantis (Peppler & Solomou, 2011; Barab et al., 2010).

DIY as an Artistic Practice

In addition to the abundance of interest-driven arts learning happening on screen, there is wealth of activity that uses new technologies and creative coding in sculptural or Do-It-Yourself (DIY) productions. In recent years, scholars have had an interest in studying creation, sharing, and learning with new technologies through Do-It-Yourself (DIY) communities (Guzzetti, Elliot & Welsch 2010; Kafai & Peppler, 2011). Educators and researchers alike are interested in DIY communities because of the time youths spend pursuing their interest-driven activities and the potential to develop or expand skill sets. Dale Dougherty, the founding editor and publisher of *MAKE* magazine, states that the "most important thing about DIY is that it portrays the idea that you can learn to do anything" (2011a/2011b). The success of DIY and showcase events like Maker Faire—an annual weekend festival dedicated to the Maker movement (i.e., a growing community of young people and adults who are designing and building things that was recently highlighted in a White House event dubbed a "hangout"[1]) that showcases diverse creative innovations in technology, arts, crafts and fashion—is largely based on exposure; when you see someone making something, you want to make it yourself. New and interesting DIY technologies include printers that allow you to print 3D objects, smart fashion, and fabrication tools that merge digital and physical materials (Gershenfeld, 2005). Artists of all ages are widely using FabLabs, which enable people to access digital fabrication tools that once were only available to industries. Although DIY is a deliberately broad scope of making that includes sculpture, robotics, and arts and crafts, many artists draw on multiple forms. For example, popular

media artist Cory Arcangel was recently featured in *The New Yorker* and has exhibited at the Whitney Museum, the New Museum, and the Museum of Modern Art (Scott, 2011). Arcangel is perhaps best known for hacking video games, but he also uses a variety of media to explore the relationship between technology and culture.

Artists are using popular online communities, such as makezine.com or instructables.com, to showcase their art work and share their process with the broader community, alongside hundreds of thousands of videos, photos and tutorials on virtually any topic (Torrey, McDonald, Schilit & Bly, 2007). Popular to these expressions has been the use of the open-source construction kit, Arduino, which designers around the world use to create projects. One permutation of Arduino is the e-textiles community built around the LilyPad Arduino kit (Buechley & Eisenberg, 2008). Electronic textiles enable artists to integrate sensors and LED lights into clothing, which can be programmed for informative feedback and artistic purposes, such as interactive dance costumes that can control electronic music software in real time (Buechley, Peppler, Eisenberg, & Kafai, 2013).

Does Making, Creating, and Performing Matter?

Looking at the diversity of forms, tools, and practices that youths are engaging in their interest-driven activities, we must ask about the significance: Does making, creating and performing matter? Does it provide any additional advantages over other out-of-school pastimes? Sociologist and media theorist David Gauntlett connects the popularity of Web 2.0 with the rise in "everyday creativity"—the phenomena of individuals creating something novel unto themselves (2011, p.1). Building on the work of Ivan Illich (1973), Clay Shirky (2008), the 19th-century socialist and tapestry-weaver William Morris, and others, Gauntlett believes that people's efforts to make something themselves rather than passively consume what's given to them could have significant civic, political and environmental ramifications. Consider James Catterall's (2009) analysis of the long-term outcomes of nearly 12,000 students followed through age 26. Catterall explored the impact of intensive involvement in the visual and performing arts during secondary school. Compared to their peers who were not involved in the

arts, Catterall found that young adults who engaged extensively in arts were more successful in college and more involved in community service and pro-social activities.

Further, Brigid Barron, in her analysis of the digital practices of 358 Silicon Valley youths, found that teens who create digital media projects, play video games, and edit/design social network pages and blog posts demonstrated constructive, critical, and social dispositions. Compared to their peers who engaged in little or no creative digital production, makers were more likely to:

Constructive Dispositions	Critical Dispositions	Social Dispositions
• Believe that they can come up with interesting new ideas • Discuss a hobby using the Internet at least once per week • Demonstrate Internet skills • Feel confident with computing • Show interest in learning more in the future	• Seek other sources to validate online information, such as books, teachers, and encyclopedias. • Believe they have gained new perspectives on social issues such as poverty, violence, and civil rights	• Predict they will create media for social change in the future • Create and share media with a political message once a week or more

Figure 4.1 Brigid Barron found that makers scored consistently and significantly higher in the above dispositions than non-makers.

Barron suggested that some digital hobbies, such as creating digital media projects, offer more opportunities to develop new literacies and dispositions than others. Her findings parallel many conclusions from the Catterall 2009 study. From these two large-scale surveys, we get the distinct impression that

making matters, not just because it improves academic outcomes like obtaining a college degree but also because it develops the creative, confident, and tech-savvy dispositions that are important to 21st-century learning.

In the next chapter, we look at the formal and informal communities of interest that can further support arts learning for young people, building on their enthusiasm for making and creating with new media resources.

NOTES

1. http://www.whitehouse.gov/blog/2013/03/27/white-house-hangout-maker-movement

COMMUNITIES THAT CAN SUPPORT INTEREST-DRIVEN ARTS LEARNING

One of the major findings to emerge from a survey of today's participatory culture is that youths are increasingly assuming public roles as artists, performers, designers, editors, and directors of creative products and are sharing their work through social media platforms (Ito et al., 2010). Although prior ethnographic research suggested that little creative design and reflection occurs when young people work alone at home on their computers (Giacquinta, Bauer, & Levin, 1993; Sefton-Green & Buckingham, 1998), well-designed learning environments can encourage youths to explore new kinds of art learning to a greater degree than they would be inclined to do on their own.

As we look across these learning communities, we gain a better sense of the enduring role that institutions such as libraries, museums, community technology centers, and social media networks play in supporting interest-driven arts learning. We break this review into four major categories:

1. Non-formal learning communities operating outside of the school day, which organize projects, programs, and activities in structured but non-compulsory ways.
2. Informal communities where learning happens in a casual or haphazard way. These groups can be in physical spaces such as museums, libraries, or community technology centers or at street fairs or Maker Faire events and are united by the presence of what we call "construction zones." That is, they have available resources, including tools, materials, and adult mentors, but they lack a formal organization.

3. Virtual, online communities—also informal in nature—that support art making and sharing to various degrees. Although very little research on these communities currently exists, we consider them promising because of their scope and scale.

4. Grassroots artistic movements, which have frequently resulted in entirely new art forms such as graffiti art, Krumping, and hip-hop. Often the contributions of these types of communities are undervalued in the discussions on formal and informal arts learning because there is an assumption that high-quality learning spaces must be intentionally and purposefully designed.

We believe that a mix of formal, non-formal, and informal learning spaces is a necessary and important part of the individual's whole learning system, forming what scholars have referred to as an ecological approach (Sefton-Green, 2006) to interest-driven arts learning.

Non-Formal Communities

Non-formal communities are perhaps the most researched and understood category (Hirsch, 2005; Cole & The Distributed Literacy Consortium, 2006). They differ from informal learning spaces because they emphasize goal-oriented learning and organized programming determined and implemented by adults. Proponents believe that these learning communities can support large numbers of young people while also allowing individual students to pursue their interests at their own pace (Moll, Amanti, Neff, & Gonzalez, 1992). In the following passages, we present some exemplary models of non-formal learning, all of which target non-dominant youth.

- **Musical Futures** started in 2003 as part of the Paul Hamlyn Foundation's investigation of why many teens were not pursuing music education despite their passion for music. As a result of consultations with many leading experts in the field, the Musical Futures curriculum was developed, offering a series of models and approaches that teachers and other professionals can adapt to their settings and instructional styles. The emphasis is on guiding and modeling, rather than direct instruction; experienced students act as peer leaders. For example, youths incorporate their favorite pieces and genres into the curriculum, teach-

ing each other how to play simple parts on their instruments either through notation or modeling ("by ear"), depending on varying levels of prior musical ability. Musical Futures is connected to a virtual space, called NUMU, where participants can publish, share and critique one another's work.

- **Children's Creativity Museum** (formerly **Zeum**) is a multimedia arts and technology museum, part of a nonprofit, community-based organization in San Francisco that provides hands-on experiences in animation, sound and video production; live performance; and visual arts. Visitors across age groups can use art and technology tools to create clay animation, make music videos, compose a soundtrack or experiment with digital art. Museum exhibits are set up as a series of progressive stations that take the participant through the process of creation for the various art forms. For example, in the clay animation room, individuals or families can gather at the center tables to sculpt figures, using a wire frame and clay to fill out the body. Once the figures are complete, artists can set up a backdrop for the production and use the simplified video equipment to create a stop-action animation that they can later save on a DVD. Work in its final stages is also broadcast internally to a central space in the museum.

- **Weekend Arts College (WAC) Performing Arts and Media College,** a British-based organization, provides training opportunities in the arts for 1,100 young people (ages 5 to 25) a year. With an international reputation for innovative teaching and access to cutting-edge media and arts projects, WAC Performing Arts and Media College offers professional-standard classes to talented young people from low-income backgrounds. WAC emphasizes the "transferable" skills young people learn from arts experiences, in addition to a focus on cross-disciplinary training where students learn art across a range of modalities. The college also provides dedicated training for digital media artists and specialized courses for young people with learning difficulties.

Informal Communities

Content learning is an unplanned or unintentional byproduct of informal communities where youths congregate based on a shared interest and un-

expectedly gain insight through activities that were otherwise designed to be "just for fun." An organizing principle of many informal communities is that if youths engage in design, learning will happen without intentional curricular scaffolding.

Opportunities to encounter and work with popular media texts are also prevalent across these spaces; some form of viewing is often part of the informal learning ecology. Even programs that target younger children (ages 5–12), such as Australia's Out of School Hours Care (OSHC), contain strong media and design components. Organizers believe that consumer/ fan practices can inspire reflection, learning, and production not found in more structured settings (Vered, 2008).

Below, we present examples of physical communities, although informal learning also thrives in some virtual communities. It's important to note that both types of communities tend to be hybrid in nature. For example, the Computer Clubhouse Network includes physical spaces but also has a virtual Intranet that connects young people across the globe and allows those within the network to share and comment on one another's work. Likewise, admirers of graffiti art have been invited to local happenings through Flickr. com, and comics and manga fans have come together to showcase artwork at Comic-Con.

- **The Computer Clubhouse Network** aims to give youths, especially those in economically disadvantaged communities, opportunities to become fluent with new technologies (Kafai, Peppler & Chapman, 2009). The first Clubhouse opened in 1993, in response to reports of teens sneaking into the Boston Museum of Science to design high-tech robots and sculptures instead of attending school. Today, more than 100 Clubhouses exist worldwide and are supported in part by network partners but are sustained through their ties to local non-profit organizations. With the realization that youths who were disengaged from formal schooling were still interested in creative spaces to explore and design, the Computer Clubhouse Network adopted a constructionist approach to ensure that participants had opportunities for discovery and personal expression (Papert, 1980). Mitchel Resnick, one of the founders of the

flagship Computer Clubhouse, says that if youth "are interested in video games, they don't come to the Clubhouse to play games; they come to create their own games…. In the process, youth learn the heuristics of being a good designer: how to conceptualize a project, how to make use of the materials available, how to persist and find alternatives when things go wrong, how to collaborate with others, and how to view a project through the eyes of others" (Resnick, 2002, p. 34).

Clubhouses strike a balance between structure and freedom in youths' learning. Sample projects are displayed on walls and shelves and are accessible through the local server (connected to all desktop computers in the Clubhouse) as well as on the Clubhouse network. These projects give youths multiple entry points into creative production, as well as a sense of what is possible. The centers also provide professional-grade production software and guidance from staff mentors, professionals, peers and volunteers.

- **YOUmedia** and the associated Learning Labs consist of a rapidly growing network of more than 30 public libraries, museums, and community-based organizations across the United States. The spaces are dedicated to teens in their exploration of digital media. Within these settings, designers allow for "hanging out, messing around and geeking out" (Ito et al., 2010) and make a special effort to develop teens' critical thinking, creativity, and digital media skills through hands-on activities. YOUmedia Chicago, for example, provides an open, 5,500-square-foot meeting space on the ground floor of the Chicago Public Library's downtown center, which serves close to 200 youths per day. At this YOUmedia site, any teen with a valid Chicago Public Library card has free access to equipment, including still and video cameras, drawing tablets, and video- and photo-editing software. With the support of mentors from Chicago's Digital Youth Network as well as librarians, young people create rap music, documentaries, machinima, robots, and other digital media and art forms.

The design of the YOUmedia learning space encourages individual and collaborative work and also provides a safe and open area where teens can hang out and observe work created by their peers. YOUme-

dia teens also have access to a version of Remix World, a social learning
network where teen participants can share and reflect on their work.
The project is in the process of scaling up to more than 40 locations
nationally through the Learning Labs Project, with the combined sup-
port of the Institute of Museum and Library Services (IMLS) and the
John D. and Catherine T. MacArthur Foundation.

- **Maker Faires, Young Makers, & Maker Education Initiative:**
Large events such as Maker Faires, 4-H festivals, cosplay festivals (a
type of performance art where participants don costumes represent-
ing characters from a work of fiction), and Comic-Con (a fan con-
vention dedicated to comics, manga, video games, movies, and more)
draw people together because of their mutual love of sharing what they
produce. These types of events attract diverse crowds and leave
attendees empowered with the notion that they can create (almost)
anything, presenting a compelling case of interest-driven arts learn-
ing in a digital age.

The Maker Faire is a division of Maker Media, run by O'Reilly
Media. Through a series of annual events across the country, Maker
Faire enables teens to challenge their imaginations through invention.
According to statistics gathered by the New York Hall of Science:

> The [World] Maker Faire [in New York] hosted over
> 80,000 visitors in 2010 with 1,000 attendees as "mak-
> ers"—the Maker Movement really begins with the Mak-
> ers themselves—who find making, tinkering, inventing,
> problem-solving, discovering and sharing intrinsically re-
> warding (New York Hall of Sciences, 2010, p. 1).

Maker Faires, through their Young Makers programs and their new
Maker Education Initiative, also explicitly encourage young people to
see themselves as creators. Connected to Maker Faire and hosted in
the Exploratorium museum in San Francisco, Young Makers provides
a space for youths to work with mentors in the development of cross-
disciplinary projects that meld math, science, and art. Young Makers
meets monthly at the Exploratorium, and finished projects can be ex-
hibited and explained at Maker Faire.

Dale Dougherty, the founder of Maker Faire and editor of *MAKE* magazine, likens the Young Makers programs to garage bands (Dougherty, 2011a). No formal education is required. Instead, participants self-start their own projects and find others with a similar level of ability and interest with whom to collaborate. After committing the time to practice together, participants "perform" for others and get feedback.

Virtual Communities

There has been extensive research from a wide range of disciplines about the emergence and validity of communities in virtual spaces (see Baym 1995; Rheingold, 1993; Wilson & Peterson, 2002). Some noted characteristics of online communities include membership, a shared purpose, an interest or affinity, formal policies, and a technical (although implicitly always socio-technical) infrastructure. Scholars have investigated overall communication patterns within online communities (Lanamäki & Päivarinta, 2009), the nature and strength of members' relationships (Ryberg & Larsen, 2008), the flow of knowledge (Heidelberger & Sarnikar, 2008), varied motivations for participation (Bishop, 2005) and how governance issues are negotiated and supported by technical features (Forte & Bruckman, 2008). Other questions about virtual communities remain, such as whether or how their longevity differs from physical communities.

In the meantime, two areas of online community studies are particularly relevant to interest-driven arts learning in the 21st century. The first is how to best design communities that can support creative production and expression. Researchers have looked at the effects of discussion moderation on communities (Ren & Kraut, 2010); methods to increase traffic, introduce new members (Kalaitzakis et al., 2003); increase member participation (Ren et al., 2012); and the design of full inclusion of diverse participants (Basdekis et al., 2006). David Gauntlett (2012), a British sociologist and media theorist collaborating with the BBC, suggests a framework that builds on public service broadcasting but with digital age updates. It would include giving youths the tools to create and share their own media rather than designing media to be broadcast to them. Gauntlett's model would encourage activities and content that foster flow (Csikszentmihalyi, 2008) and playfulness

and provide spaces for hanging out and discussing, with the goal of promoting interest in the creative aspects of production. Taken together, Gauntlett's recommendations can be seen as a set of guiding principles to foster creativity, collaboration, and learning through digital tools.

The second question is how creative production plays out in online contexts. Various cultural and learning theorists have outlined the qualities of communities, online and off-line, which facilitate participatory creative practices (see Gee & Hayes, 2009), including low barriers to entry, informal mentorship, and sharing of resources. Despite the potential for expanding arts learning through virtual communities, there are some concerns about authorship, ownership, and attribution (Diakoloulos et al., 2007; Luther et al., 2010a/b; Perkel, 2010) because many artists remix and appropriate existing work.

With these caveats in mind, we present three compelling virtual communities with potential for expanding interest-driven arts learning:

- **Scratch.** Developed at the M.I.T. Lifelong Kindergarten Lab, Scratch is a block-based visual programming language designed to facilitate media manipulation for novice programmers (Resnick et al., 2009; Maloney et al., 2008). Since its introduction in 2008, the online Scratch community (www.scratch.mit.edu) has quickly grown to more than 1.2 million registered users and nearly 3 million uploaded projects. All projects on the website are shared under a Creative Commons attribution license. "Scratch Design Studio" challenges encourage creation and sharing by providing users with a basic design concept. A forum at Scratch.mit.edu lets new users introduce themselves and ask basic questions about programming. There are also places to pitch ideas for new projects and seek collaborators.
- **deviantArt** (www.deviantart.com) is an online community created as an exhibition and discussion space for user-contributed artwork. The site hosts photography, digital art, traditional art, folklore, literature, film and Flash-based creations, and offers resources, tutorials, and stock photos for public use. With more than 14.5 million members and 100 million submissions (an average of 140,000 per day), deviantArt is one of the most popular websites in the world (Perkel, 2010).

- **Teen Ink** (www.teenink.com) is a magazine, website, and book collection created by teenagers and published through the non-profit organization, Young Authors Foundation. Teens can submit their work to the community through online and offline spaces. Teen Ink publishes poetry, fiction, non-fiction, essays on important issues, and different types of art, such as drawings, computer graphics, paintings, woodcuts, and photographs. The community can rate and discuss the submissions with the author/artist.

See the appendices of this report for a longer listing and evaluation of learning communities created by and for teens.

Grassroots Movements

Historically, grassroots movements have played a formidable role in arts learning. Such communities (whether virtual or physical) can involve a semi-formal space that lacks direct instruction from adults but can leverage knowledge of the field (Moll, Amanti, Neff, & Gonzalez, 1992). Much of the outsider art created in today's landscape, including the South LA Krump culture (Peppler & Kafai, 2008), the Gee's Bend quilting community, and manga, has emerged from the grassroots movement. Often these community-based movements reach a critical mass and are eventually appropriated by the institution of art. We believe that a community of practice emerges within these groups, which slowly produces a new genre of art and high-quality work. Although we have little formal research about these communities, we have seen evidence of most of the eight Studio Thinking habits of mind taking place within them—developing craft, engaging and persisting, envisioning or imagining what's possible, expressing ideas, observing, reflecting on the process, and stretching and exploring.

The following cases introduce three grassroots arts movements that have strong youth leadership:

- **Krump.** In the same way that breakdancing defined underground urban culture in the 1970s and '80s, Krump (a street dance form originating in south-central Los Angeles and defined by its intense energy, expressiveness, and aggression) is becoming embedded within the physical vocabulary of urban neighborhoods. Krump communities include for-

mal and unstructured forms of learning. On the more formal end of the spectrum, membership in Krump communities is dependent on one's inclusion in "families," which are organized around the mentorship (in both dance, as well as life) from a more experienced Krump dancer. Conversely, the dance form evolves when large groups of Krump dancers engage in "battles" or other forms of exhibition, after which dancers convene with their families to incorporate or respond to the newest moves from the event. This ensures the perpetual development of the dance form, which operates out of a widespread form of communal agency (Peppler & Kafai, 2008).

- **Hip-hop.** Like Krump, hip-hop originated as a form of non-violent confrontation for marginalized, inner-city youth—an alternative to gang violence. Unlike Krump, hip-hop embodies several forms of artistic expression, including music, dance, fashion, dialect/slang and design. From its underground beginnings in New York City during the 1970s, hip-hop has become one of the world's most renowned youth cultures, resonating with disenfranchised youths across national boundaries and racial lines (McBride, 2007). Although there is a heavy influence from U.S. culture, other countries have transformed hip-hop with their own musical traditions and messages. Participation in the larger hip-hop community, therefore, entails becoming well acquainted with the innovations that occur not only across regions but within each hip-hop (arts) strand. As Jeff Chang has observed, "the essence of hip-hop is…[that] competition and community feed each other" (Chang, 2005, p. 90).

- **Graffiti Art.** Graffiti is also an international movement, celebrated through YouTube videos, Twitter feeds and clothing brands. Although a scourge to city officials and citizens who consider it vandalism, graffiti earned critical accolades as far back as 1979 when graffiti artists Lee Quinones and Fab 5 Freddy were provided a gallery opening in Rome. Graffiti also has been leveraged in several marketing efforts, such as an infamous 2001 Linux campaign, and is increasingly popular in international art markets.

The uneasy relationship that this art form has with law enforcement relegates the modes of community membership, unique ico-

nography and unwritten codes of conduct to the underground. Most graffiti artists operate in groups of 5 to 100 members, also known as crews. Although not necessarily territorial, crews usually spring from neighborhood ties. The main objective of the crew is to paint and take care of one another, and connections between crews exist to expand networks. The graffiti art genre, like the Krump movement, evolves through a sense of one-upmanship, as writers adapt to new innovations by refining their original style and/or executing graffiti in increasingly daring locations. Within the broader graffiti community, an ethical code pervades. The general consensus is that writers should never tag or otherwise mark religious institutions, cars, or private residences or paint over other writers' work, opting instead for abandoned or corporate properties.

Summary

Creative communities can support interest-driven arts learning and can assume many forms, as this chapter illustrates. Many physical communities are formed within greater organizational structures that bring youths together under a common roof and, to varying degrees, common interests. Online communities, too, are provided a shared (digital) space by an organization or individual, within which a virtual community or grassroots movement can emerge from a mutual "affinity" (Gee, 2004) for a form of artistic expression.

Despite these similarities, it is important to recognize the ways that an organizational structure and a community are *not* the same—an afterschool environment can be established that adopts an informal learning framework and the trademarks of an artistic community may still be absent. Organization structures are top-down; they reflect what people or organizations want to provide for youths. Communities, however, emerge from a *needs* basis—in this case, a need within the youth community to create and participate in the arts. As such, they can emerge from within an organizational structure, but they can also thrive without one. Krump, for example, started out as little more than youths coming together to dance. With time, an ad hoc community was formed around the practice, bringing formal structure in the form of organized competitions, battles and performances. Similarly,

the first Computer Clubhouse was created due to a genuine need to provide access to technologies that were free of cost. When these needs are met, youths gravitate toward such spaces. Organizational structures, meanwhile, are responsible for maintaining a physical location or website where community activity takes place.

Each of the communities highlighted in this chapter possesses unique attributes that shape youths' motives for membership, highlight barriers to participation, and suggest specific dynamics that determine group inclusion, exclusion and youths' sense of affiliation within the community or space. More research is needed to determine whether certain environments would be better served by the presence of physical versus virtual artistic communities, although several physical locations with well-connected adults seem to be doing important work with non-dominant youths in marginalized communities.

INVITING AND SUSTAINING
PARTICIPATION IN THE ARTS

Looking across the diverse communities, practices, and genres of art making introduced in this report, we see a range of potential entry points for interest-driven arts learning but also some barriers to greater participation. As Clay Shirky argues, the largest gap in some respects is between doing nothing and doing something for the first time (2008). We have an opportunity to recognize and celebrate youths' participation in interest-driven arts production, regardless of the form it takes, and envision interest-driven arts learning as inclusively as we can.

Scholars studying Web 2.0, social media, DIY, and the new participatory culture have shown that people like to make things and share them with others (Gauntlett, 2011, 2012; Shirky, 2008; Dougherty, 2011b), which helps explain the presence of 80,000 attendees of the Maker Faire each year and the vast number of people committing volunteer time to projects such as Wikipedia, Scratch, and other open-source communities. For many teens, however, the inclination to make art competes with a hard financial reality. Bypassing a paying job (even one that earns minimum wage) in order to socialize and make art at the local library isn't a choice they can realistically make.

Paid positions and opportunities to make money could be a way to keep this age group engaged in the arts. Some youths, like Ashley Qualls of WhateverLife, start their own Web-based companies, incorporating entrepreneurial skills into their creative endeavors. Others seek training and development opportunities for future employment as Web designers, animators, arts instructors, or graphic designers. Additionally, deviantArt, Etsy and similar websites allow youths to sell their artwork, prints, T-shirts, and other gear to

earn modest sums of money. Among grassroots movements, the Clowning dance form (the precursor to Krump) originated as a form of entertainment for children's birthday parties. Options for the future include offering payments to teen mentors who have been part of a community for some time, creating gallery spaces where teen artists can earn a modest sum from sales or admission, and providing small start-up grants for continued education.

Another substantial barrier to youth participation in the arts is the general institutional disregard for a number of forms of artistic production prized by young people. As mentioned previously, youths are producing art in genres such as manga, comics, video, and photography, which are not always welcome or encouraged during the school day or as part of formal studies. The continued divide between high art and popular/everyday art distracts educators from the important issue of how to get younger generations more involved in the arts.

Consider the experiences of Freddie Wong, a film student at the University of Southern California, who uploaded a video of himself playing an intricate and complex song by the rock trio Rush on the "expert" setting of Guitar Hero. Although many have dismissed Wong's video as a pale imitation of true music performance, it has attracted more than eight million views and 43,000 comments and earned respect from ethnomusicology scholars such as Kiri Miller (2009). As suggested in an earlier vignette, "From Video Games to Violins," these types of performances can lead to greater interest in the arts, acting as a "doorway in" to traditional forms of music (Peppler et al., 2011; Wiggins, 2009).

Moreover, the ability to leverage popular media in youths' art is one of the reasons that Scratch has been so successful. One of the few computer-programming environments to have wide appeal among youths, Scratch enables them to share and remix media to extend their popular culture interests. Prior research has found that the opportunity to pull your favorite music or image into a program is a successful starting point for a new project, but it's also significantly correlated with persisting with the work compared to peers who start with a more general idea (Peppler, 2007).

As we seek to capitalize on media culture to invite and sustain participation in interest-driven arts learning, we must recognize an important dis-

tinction between what MIT Media Lab professor Mitchel Resnick calls "edutainment" (2006) and leveraging what computer scientist Tony DeRose of Pixar Animation Studios calls "hijacking" youths' interests and popular culture for making and doing art (Dougherty, 2011a). As Resnick notes in his critique of edutainment software:

> Often, the creators of edutainment products view education as a bitter medicine that needs the sugar-coating of entertainment to become palatable. They provide entertainment as a reward if you are willing to suffer through a little education. Or they boast that you will have so much fun using their products that you won't even realize that you are learning—as if learning were the most unpleasant experience in the world (Resnick, 2006, p. 195).

Often edutainment comes in the form of celebrities endorsing products or programs for youths. In contrast, "hijacking" youth culture suggests a different approach, where we start with the kinds of media (e.g., music, video games, movies and books) that appeal to young people and ask them to imitate or make something that extends these interests. Examples include Harry Potter fanfiction writing, creating the next level of a favorite video game, or playing a favorite song on the piano. In this way, youths can build bridges between their interests and the arts.

The opportunity to gain mastery is another key element of youth participation and development in the arts. Research demonstrates that people seek mastery, which builds from the desire to get better and better at something that matters to them (Pink, 2011). And as Clay Shirky notes, young people are more likely to have higher-quality online conversations about work when the standards of quality are clearly identified by the community (2008). Online communities like deviantArt and video games like World of Warcraft already allow for mastery, which motivates unpaid players to elevate their reputations through leveling up or gaining "expert" status. This process points to how new media can shrink the divide between experts and novices, particularly in music and movie making where a new level, "Pro-Am," the expert amateur, has emerged that is educated entirely outside of formal institutions (Leadbeater & Miller, 2004).

We also know that people are more likely to engage and persist in activities that they believe fulfill a greater purpose. For youths, such altruism could include trying to earn money to ease financial stress on their families, producing art for social good, teaching those who might be struggling, and networking and sharing new ideas. As prior research has demonstrated (Catterall, 2009), youths exposed to the arts are more likely to volunteer or "do good" in their mid-20s.

Art also enables youths to re-envision their surroundings. In 2004, for example, a group of youths from Atlanta started a non-profit organization called Wonder Root (http://www.wonderroot.org/aboutus.htm) to unite artists and inspire social change. For a small membership fee, members have access to a production and recording studio with instruments, digital video-editing software, high-end computing equipment, a darkroom, a ceramics studio, a multimedia presentation room, and a library for individuals to realize their creative vision at a low cost. The storefront location houses a performance space where musicians, speakers and performers can publicly showcase their work. The center also features outreach workshops and programs to encourage its artists to bring their art into the local schools and give back to the greater community. As the group's mission states, "We believe that artists have the potential to change the world. Musicians, photographers, writers, filmmakers, and artists of all other mediums have the ability to communicate globally moving freely through the barriers of language and geographical restraints." Groups like Wonder Root are working to teach youths to use the arts to impact our everyday lives.

Sustaining Interest in the Arts

Through all these efforts, it is critical to consider ways to not only encourage youths to initially explore artistic production, but also to sustain their involvement. The Harvard Family Research Project identified five factors associated with high retention in organizations:

- Offering youths leadership opportunities
- Having adults involved who are well-informed about youths' activities and interests and who publicly recognize their accomplishments

- Providing community-based programs rather than at school
- Scaling up so that more than 100 youths at a time can be involved
- Scheduling regular staff meetings to discuss program-related issues.

The Harvard research also noted that having choices and specialized programs that prepare youths for the future workplace are important as well. Involving parents and families also can sustain youths' involvement in the arts. The main question that emerges from this research and other studies about inviting and sustaining participation in the arts is whether the identified factors translate into virtual worlds.

Progression Pathways

There are two areas of research that have important implications for our discussion: The first comes from Mimi Ito and colleagues' work (2010) on interest-driven and friendship-driven networks, which implies that youths can move along a trajectory between "hanging out" (i.e., socializing with peers) and "messing around" (i.e., experimenting with new media and developing expertise).

At this point, we don't know whether young artists are more likely to join social networks because they need a place to store virtual portfolios of their work or whether social networkers become interested in producing content because they are inspired by what they see others doing. Although it is entirely possible that friendship-driven genres of participation might transition to more serious forms of creative production, the linear progression may not be representative of all youths. For example, some may be interest-driven from the start rather than merely concerned with socializing with peers. These youths may be using digital media and social networks to connect with others because there is no one in their local networks who has similar interests.

As we investigate effective connections between interest in new media and long-term participation in the arts we can look to examples of programs that have helped teens cross over the divide. Recall YOUmedia, which provides a place for youths to explore new programs and tools informally and then lets them sign up for workshops on digital music produc-

tion, digital video production, radio and podcasting, graphic design, spoken word, or gaming and blogging. Beyond the accommodation of different types of engagement with new media, the success of YOUmedia is largely based on having professional artists work directly with youths. Nichole Pinkard and colleagues have observed that having adult mentors who are

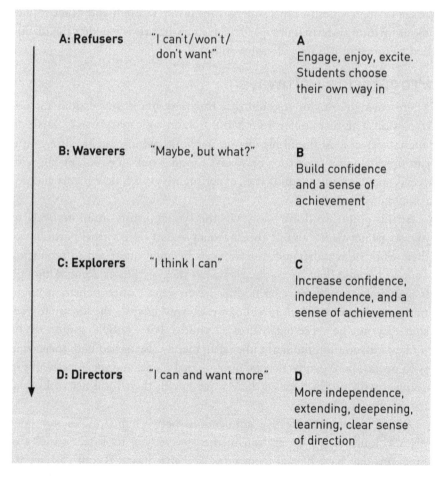

Figure 6.1 Sample Progression Pathway Based on the Work from the Musical Futures Project (Price, 2006)

active professional artists is an important starting point for youths' creative engagement, but that those same artists/mentors must also undergo professional development to ensure that they have the right combination of **technical skills** (a presence in Web 2.0/social networks, knowledge of new media tools, and an understanding of a mentor's role), **cultural capital** (the ability to relate to youths as well as the credibility in their art form), and **pedagogical knowledge** (how to teach project-based learning strategies, critique youths' work, and incorporate new media literacies). The mentors then serve as brokers, inviting youths to pursue their passions and then supporting their development in the arts.

The second example of progression pathways comes to us from the work of Musical Futures—the pedagogical model for bringing non-formal teaching and informal learning approaches into the music classroom—to support young musicians and extend their music education (Price, 2006). Although this work has been developed within the context of music, we believe that it applies to other art forms and interest-driven arts learning in general. Research from the Musical Futures project has conceptualized developmental pathways, based on speaking to young people about their aspirations and observing their responses to projects. As a result, this research identifies four typical participant archetypes (Price, 2006, p. 4):

1. **Refusers**—those with little or no inclination to engage with music other than as consumers. Refusers are perhaps the most complex group to understand because they carry cultural and social baggage that often keeps them from participating. Skilled administrators of the curriculum, with strong inter-personal skills and persistence, can usually persuade these young people to shed their reluctance and defensiveness.

2. **Waverers**—those who have an interest in music but are not sure what they want to do or how to participate. Conventional music skills may often be rudimentary and confidence can be fragile. Participants are more likely to feel comfortable finding "their own way in" to projects. Having a negative experience with performance can turn Waverers into Refusers.

3. **Explorers**—those who have acquired some skills and confidence but have not yet found a good match for their interests. Youth making the transition from primary to secondary education often fall into this category.

4. **Directors**—those who have already accessed a range of opportunities and are developing performance and rehearsal skills. They are confident among peers and motivated, with a clear sense of musical direction. They often form their own groups and are eager to extend their depth and range of skills.

Identifying young people's interests and skills helps adult mentors, professionals, and the youths themselves to co-construct progression pathways. Figures 6.1a and 6.1b suggest how different learning goals might be set at various stages.

To understand how this trajectory could play out for individuals, let's consider a visual representation (see Figure 6.2) of one teen. Joe starts as a reluctant participant with no prior involvement or encouragement in music at home. After Joe becomes involved in a variety of activities across formal, non-formal, and informal settings, he records his first music CD for sale at gigs. We can imagine Joe's identity evolving as he moves from an initial Refuser to ultimately a Director of his interest-driven learning in the arts.

One final note about the Musical Futures pathways is that there are different activities targeted to each group of participants, ranging from music "taster" workshops to professional recording sessions. The intent of these activities is to meet youths wherever their current interests in music lie and get them excited about the possibilities of making and performing music. Note that the activities recommended by Musical Futures all position learners to actively reformulate their conceptions of music through the production of meaningful artifacts. Thinking about different strategies to engage learners at various points along the continuum is developmentally appropriate. Strategies that might engage Directors who want more opportunities to create professional-quality work (such as providing supplies or resources for their latest projects) probably won't work for Refusers who aren't yet interested in the arts. Instead, Refusers would first need an engag-

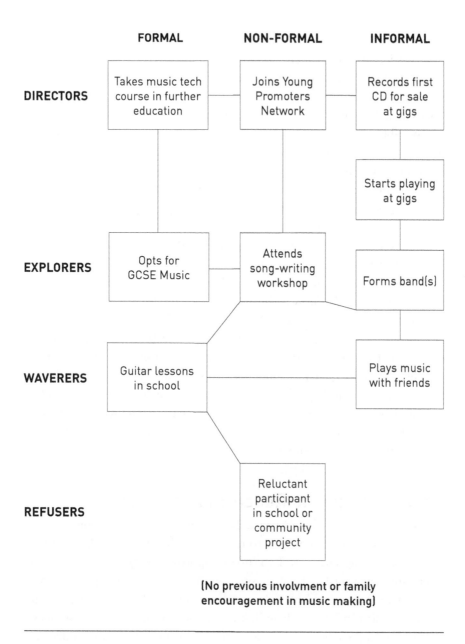

Figure 6.2 Musical Pathway Case Study No.1: Joe (Price, 2006, p.6)

ing introduction, such as rhythmic video games like Rock Band that are novice-friendly and let them play popular music.

New efforts in interest-driven arts learning should build on this work, seeking to determine its applicability to other visual and performing art forms as well as how well it translates into the virtual spaces. For example, is it possible to use a similar progression pathway solely in online communities? Is the distinction between virtual and physical space-based learning important to youths today? If so, what are the major differences? Additionally, how do we support youths across a variety of programs, communities, and platforms in their interest-driven arts learning activities? Because interest-driven arts learning is inherently interdisciplinary, we need to know more about supporting youths to explore a wide variety of domains.

To our knowledge, no such programs or research currently exists that could shed light on how to support and encourage youths in these types of explorations, as well as how pathways can be formed across formal, informal and non-formal settings. The MacArthur Foundation's recently launched "Connected Learning" initiative (http://connectedlearning.tv/what-is-connected-learning), together with the Mozilla Foundation, has supported the creation of the Hive Learning Networks in Chicago and New York (and soon to grow to additional cities throughout North America). The Hive Learning Network is designed to foster production-centered and interest-driven learning opportunities across schools, libraries, museums and online communities. These initiatives might begin to broaden our understanding of how to connect learning across settings.

New Strategies to Reach Youths Directly

An alternative approach to financially supporting centers or communities to advance teens' engagement is to reach them directly through social media-based funding channels. Two broad opportunities exist in this area: (1) leveraging new social technologies to identify underserved populations and disadvantaged young people who are interested in the arts, and (2) using various media platforms to help link them with the appropriate resources.

The first approach leverages social media technologies to organize and locate youths in need of services, supplies, and tools. For example, Usha-

hidi (www.ushahidi.com), a nonprofit technology company that specializes in developing free and open-source software for information collection, visualization and interactive mapping, has built a general set of tools for "democratizing information, increasing transparency and lowering the barriers for individuals to share their stories." Originally developed so that Kenyans could report on acts of violence in real time, the tools could be used to gather any type of information, including potentially locating underserved youths who are interested in the arts.

The second approach directly enlists people to assist in high-needs areas. Consider the "1 Kilogram More" project, which aims to improve education in poverty-stricken areas. Travelers are asked to carry an extra kilo of books, dictionaries or CDs with them to give to poor children. Similar strategies are being used in the United States through the National Lab Network, which connects teachers and students with expert mentors to assist on particular projects. Meetup.org is also being used by home-school networks to organize outings and share information.

Alternatively, funding agencies can search for ideas and individuals through social media services dedicated to pairing donors with students or creators in need. Kickstarter (www.kickstarter.com), for example, represents a new form of commerce and patronage. It bills itself as "the largest funding platform for creative projects in the world." Creators representing film, photography, music, dance, public art, comics and other creative fields post project proposals to the website, along with a fundraising goal and deadline. Visitors to the site can discover new ideas and become financial backers of their favorite projects by making a financial transaction directly through the website. However, projects must reach their funding goals before the deadline or no money changes hands. This requirement is designed to protect creators from having to develop products with insufficient funding, as well as provide a risk-free environment to test new ideas.

A similar website, ScholarMatch, connects donors to college-bound teens whose families can't afford the cost of attending. To motivate students, donors receive monthly updates about their academic progress. Although not an arts-specific project, ScholarMatch lets applicants identify their desired schools and majors, making it simple for potential donors to discover who

is applying for funding to pursue degrees in arts-related fields. The average scholarship goal for applicants is approximately five thousand dollars.

These platforms demonstrate the variety of ways that social media can allocate resources to specific outcomes. For example, funding agencies could ask a representative to explore projects and future arts scholars on a monthly basis to enable continual and flexible forms of financial support to flow to the informal arts learning sector. Given the relatively small financial requests made by many of these projects, foundations and other organizations could potentially make a huge difference for many students. Kickstarter, launched in 2009, and ScholarMatch, started the following year, are both so new that we don't yet have research about the efficacy of these strategies. It's worth noting that some people caution that these types of strategies employing social media run the risk of exacerbating existing inequalities. For example, youths from middle- to upper-income homes are more likely to hear about, participate in, and provide applicants with support for these opportunities. Funders could work to offset this potential disparity by partnering with organizations (schools or after-school centers) to ensure that youths from non-dominant groups are fairly represented.

7

CHALLENGES AND RECOMMENDATIONS

This report has uncovered five primary challenges to interest-driven arts learning in the 21st century:

1. Conceptualizing interest-driven arts learning in new media
2. Changing perceptions of youths' interest-driven arts activities
3. Promoting equity in interest-driven arts learning opportunities
4. Designing interest-driven arts learning social networks
5. Inviting, sustaining, and supporting participation in arts activities

For each of these areas, we offer suggestions for future research, practice, and policy that build on what we know about interest-driven arts learning.

Challenge 1: Conceptualizing Interest-Driven Arts Learning in New Media

In this report, we have explained why interest-driven arts learning, with its focus on making and sharing, is such an important component of knowledge and self-expression in a digital age. However, we don't yet know enough about interest-driven arts learning to understand how it differs from prior learning opportunities in traditional visual and performing arts or in the new media arts. One challenge, therefore, is to better conceptualize the distinctive qualities of arts learning in the digital sphere.

In chapter 1 of this report, we offer a good starting point for conceptualizing interest-driven arts learning, which puts forth a framework to help articulate arts learning found in informal settings. This work highlights that

youths working in the out-of-school hours tend to move across disciplines (Kafai & Peppler, 2011) to address multiple forms of art making and modalities. This framework could be expanded upon as new research becomes available as well as tested in grassroots and other informal learning settings. Promisingly, research suggests that arts learning may be cultivated in the absence of any direct instruction through the peer culture (Maloney et al., 2008; Peppler, 2007).

What we can do now:

1. Support the continued development of a general framework for interest-driven arts learning that builds on prior models and is generalizable to diverse art forms, interdisciplinary in nature, more deeply rooted in cultural forms of expression, and can incorporate peer-to-peer teaching and learning.
2. Develop a clearly articulated guiding theory of interest-driven arts learning, which would inform future research, practice, and policy.

Challenge 2: Changing Perceptions of Youths' Interest-Driven Arts Activities

Visual culture, popular media, and the participatory culture are central to interest-driven communities. In many online forums, youths socialize and share content simultaneously. The design of many interactive Internet spaces encourages collaboration and creativity, particularly in the arts. Many Web 2.0 spaces also exalt the capabilities of the amateur—there are no boards of experts who determine which community contributions are "good enough." However, a problem arises when young people who don't recognize the cultural distinctions between high and low art forms (Spencer, 2005) discover that their preferred modes of expression aren't valued in formal arts education.

There are several reasons to start appreciating youths' work. First, youths already see it as meaningful and motivating. Second, informal arts engagement can build bridges to the kinds of knowledge and practices tradition-

ally valued in schools. Prior studies have demonstrated this trend across several domains, including rhythmic (music) video games (Peppler et al., 2011), manga (Boldt, 2009), and spoken word (Morrell, 2002). Third, embracing the incorporation of visual culture into youths' artistic production is key to inviting and sustaining participation in interest-driven arts learning, especially among teens (Peppler, 2007).

Additionally, future efforts to cultivate interest-driven arts learning should study pop culture trends because such fads and innovations often inspire youths. Examples that we have explored in this report include the relationship between popular TV programming, such as "Dancing with the Stars," and increased enrollment in ballroom dancing lessons (Kerns, 2009). Video games also seem to be popularizing some of the performing arts, including the wide-scale interest in rhythmic and dance video games (Lenhart & Madden, 2007). This landscape is poised to change again with the release of the Xbox Kinect system and the early success of games like Dance Central.

Because interest-driven arts learning looks so different from traditional participation in the visual and performing arts, it can cause people to undervalue and under-appreciate what youths are doing. Greater public awareness and investment on the part of youth-serving arts organizations, foundations, and/or thought leaders in the field in existing art practices would help, particularly by highlighting compelling research to anchor these conversations. Additionally, K-12 and afterschool institutions can help spread a public message for parents and youth to value informal arts learning practices more.

Another recommendation is to encourage youths to document their practices and support institutions that use portfolios in their admissions and hiring processes. Because young people tend to undervalue their own production practices, often dismissing their work as "messing around" on the computer, very few consistently document their work. As a result, they may limit opportunities for research, higher education, careers, and identity development. Youths need encouragement and support to collect and share their work over time, and educational institutions need incentives to value portfolio assessments as much as standardized tests of knowledge. Addition-

ally, there is a need for new tools to allow for more robust and long-term portfolio development that need to be created through collaborations between leading designers and educators.

Such portfolios of work can be tied to career opportunities for youth. Communities and institutions that help youths master and document skills essential to future careers can stimulate interest in the arts. Several of the non-formal youth centers, such as Youth Radio, have found that providing purposeful activities and access to mentors—particularly young adults— boosts teens' participation. Young adult mentors with more sophisticated skills can inform youths' artistic production, as well as support teens during important life transitions such as preparing for college and seeking employment. Having a portfolio of work that speaks to youths' abilities in the arts additionally better prepares youths for this transition to the workplace and provides a salient object for discussion with potential admissions committees or job interviews.

What we can do now:

1. Support a public engagement campaign that could counter misperceptions that parents, educators, and policymakers may have about youth engagement in new media arts. This work could also start a dialogue between researchers and broader stakeholders, including youth-serving arts organizations, foundations, and others who may benefit from discoveries in this area.

2. Encourage youths to formally document their creative work and encourage universities and businesses to incorporate art portfolios in their admissions and hiring processes. These changes could impact existing K-12 priorities that have traditionally emphasized standardized test score outcomes and, in turn, be especially significant for youths who often have few opportunities to showcase their talents in the traditional school day.

3. Work with highly successful social networking enterprises, such as Facebook and LinkedIn, to learn about youths' online posting and sharing practices. Additionally, encourage these networks to create spaces to host youths' arts portfolios or alternatively support the devel-

opment of new tools for more robust and long-term portfolio practice.

4. Partner with media and industry to extend youths' interest in fashion, dance, and music television programs to arts learning and creative expression.

Challenge 3: Promoting Equity in Interest-Driven Arts Learning Opportunities

A central tenet of a constructionist learning environment is the freedom students have to explore their natural interests with support from a community offering varying degrees of expertise (Pinkett, 2000). An ideal model for youths' informal arts engagement, constructionist learning environments provide a culture of production and sharing as well as coaching from mentors. We know from prior research that, even in privileged communities, there are very few places where youths can gather together to produce and perform in peer-to-peer settings, and we also know that these community centers are important to generating and sustaining interest in the arts (Kafai, Peppler, & Chapman, 2009). What's needed is support for new centers as well as DIY models of after-school community centers in partnership with libraries, museums, and other organizations that can stimulate interest-driven learning, particularly among youths in rural areas or in non-dominant communities.

Three promising models include the Computer Clubhouse Network, Young Makers, and YOUmedia, which emphasize youth leadership, creativity, and open exploration of materials within a social environment. Most of these models share common design features, including:

- Access to professional-quality software and equipment, including laptops and recording studios
- Affiliation with larger institutions or community-based organizations (YOUmedia centers, for example, are located mostly in library spaces)
- Programming that is co-created with youths
- Cultures that build on and respect youths' interests
- Connections to online social networks

Across most studies of non-formal and informal learning communities, adults have been shown to be important brokers in interest-driven arts learning opportunities, helping to encourage youths as they try new tools and resources and ventures and redirect them when they become stuck in the learning process. As we think about creating new spaces for interest-driven arts learning, we must provide these guides with more information and new strategies to guide youths in their use of digital media. Adults and youth mentors need ongoing training to create true constructionist learning environments.

What we can do now:

1. Learn from and support research about popular, large-scale DIY movements and virtual communities such as the larger Maker movement and deviantART.

2. Encourage new DIY, constructionist models of after-school community centers, such as the Computer Clubhouse Network, Young Makers, and YOUmedia in partnership with libraries, museums, and other community-based organizations to support interest-driven learning, especially those that serve youths in rural areas or in non-dominant communities as they play a central role in access today to high-quality digital design tools.

3. Create a series of programs that support and train adult facilitators in the principles of designing constructionist, interest-driven arts learning spaces. This includes training with new media tools and coaching (as opposed to direct instructing) young people throughout their creative processes.

4. Use new media, such as Ushahidi's geo-political mapping tools, to find youths who want to participate in interest-driven arts learning and determine what physical or virtual resources are currently available to them to better address their needs.

5. Investigate questions about the representation of non-dominant populations within interest-driven online artistic communities to shed light on lingering questions about who, what, and under what circumstances today's youth are producing art.

Challenge 4: Designing Interest-Driven Arts Learning Social Networks

Few activities are as ubiquitous in youth culture and activity as social networks, with an estimated one out of every 12 people in the world now owning Facebook accounts and more than 80 percent of the teen population maintaining profiles on social network sites. The significant presence of non-dominant youths in these spaces is especially promising. It is relatively easy to use technology to reach this target audience, and data suggests that socially networked youths are almost twice as likely as their peers to produce original artwork (Lenhart, et al., 2010). At their best, social networks represent the promise of low-cost, widespread dissemination of messages, which benefits both arts organizations wanting to attract youths to their online or physical resources and the youths who can share the art they create using those resources. The industry is also rapidly changing with agents seeking new groups and artists with large followings. New targeted interventions could use information within social networking communities to invite youths to join a group, participate in other local happenings, display their work in a curated exhibition online or at a local institution, or perform in an upcoming event.

However, there are a few caveats to consider as we seek to leverage social networking and interest-driven arts learning. First, Internet trends and tools change rapidly. In the social network industry, for example, once-popular MySpace has been overtaken by Facebook and Twitter. Any future initiatives to use social media to reach youths should stay on top of these shifts and take note of which teen groups are over- or under-represented in various online communities.

Second, although we know that social networkers tend to produce content, we know little about the quality of the work and whether it can rightfully be considered "Art" or should act as a path to artistic production generally. In this paper, we have argued for the full spectrum of content production to be under the umbrella of what constitutes "interest-driven arts learning" rather than drawing firm distinctions between different types

of art making. This is important, for example, since content creation, such as uploading photos and videos to the Internet, can lead to the type of audience feedback critique that we value in formal arts education (Lenhart & Madden, 2007). That said, most research to date has focused on youth production in a rather uncritical manner, equating all production with learning. These claims should be further scrutinized in future research as they do little to inform our understanding of arts learning. Part of this research agenda should include studying how young people define quality in their peer groups and whether this leads to self-reports of arts learning. Kerry Freedman's current research suggests that youths do, indeed, cultivate quality in their work (Freedman, Heijnen, Kallio-Tavin, Karpati, & Papp, 2013). A better understanding of how this emerges in youth-led groups as well as grassroots communities is needed to follow up on this compelling work.

Third, although new social learning networks represent an interesting hybrid space between non-formal and informal learning, their efficacy for supporting and transitioning youths from consumers to creators of new media remains largely unexamined. Further research about how social learning networks might eliminate technical and geographical barriers to arts participation seems warranted.

Lastly, we need to know more about how networking embedded in physical communities differs or relates to online social networks. Which qualities support arts learning and which are more appropriate for youths at various stages of interest? We also need to know more about the microprocesses at work in the informal pedagogies that support learning, including how peer-to-peer mentorship opportunities emerge and are supported. Under what conditions do peer communities support arts learning and how do they operate across a variety of contexts? More qualitative micro-studies are needed to document how these cultures emerge over time and the conditions in which they are supported in the community.

What we can do now:

1. Investigate the design of interest-driven arts learning social networks, including progression pathways and whether these tools need to oper-

ate within a larger ecology of learning environments to best support teens.

2. Study a range of online tools and communities to understand how they engage diverse groups of young people.

3. Investigate the quality of work produced within social networks, online communities and social learning networks in order to critically assess what counts as good work and effective learning, with particular attention to how standards emerge among peers.

4. Use social networks to cultivate audiences. Youths are more likely to explore virtual and physical communities that their friends "Like." Social networks, through algorithms of "smart suggestions," provide opportunities to publicize local events and share work.

5. Study how networking in physical communities compares with online social networks and identify the unique purposes and supporting roles of each type of network.

Challenge 5: Inviting, Sustaining, and Supporting Participation in Arts Activities

Young people, particularly teens, are a highly diverse group whose broad interests can challenge efforts to invite, support, and sustain participation in arts learning. Prior research suggests particular progression pathways in interest-driven arts learning (Price, 2006), which may help us target youths at different stages and levels of interest (see Figure 7.1). However, more work is needed to know if such trajectories can be applied more broadly in virtual environments, informal environments, and other art forms. Additionally, these progressions have been theorized within a single program so their utility in other domains and across separate formal, non-formal, informal and virtual communities should be studied more. The issue of progression pathways into early adulthood is also warranted.

Identifying a set of strategies for engaging youths who have a range of interests in making and doing art will increase the relevance of art making for a broader swath of youths. The first strategy should be dedicated to reaching the most alienated youths, which the Musical Futures project calls *Refus-*

ers—those with little or no inclination to engage with the arts other than as consumers. Ways to target these youths could include using video games (consider the 2012 "The Art of Video Games" exhibition at the Smithsonian American Art Museum in Washington, D.C., as evidence of the growing perspective that video games represent a form of art in their own right) or inviting them to events such as Maker Faires or open museum exhibits. Social networks could also be useful to this group—showcasing other teens'

Youth archetypes along the continuum of artistic production	Possible methods to initiate interest in arts activities
"Refusers": youth with little or no inclination to engage with the arts other than as consumers	• Maker Faires or open museum exhibits • Arts-based or artistic video games, like Flower (Playstation 3) and Mass Effect (Xbox 360) • Social Networks that showcase other teens' work and introduce them to opportunities to produce.
"Waverers": youth with variable interest in arts activities, may have some remarkable skills but haven't demonstrated interest in developing them.	• Hang-outs with access to technology and mentors, like YOUmedia and the Computer Clubhouse • Young Makers
"Explorers": youths with some skills and confidence in the arts but have not found the ideal outlet for their energies.	• Mentor pairing programs, like those supported through programs like the National Lab Network
"Directors": youth deeply engaged in arts activities, many with portfolios and advanced skills.	• Kickstarter campaigns to directly support youth arts project proposals.

Figure 7.1 Strategies needed to invite, sustain, and support participation vary across the spectrum of participation.

work, notifying them of a wide range of activities, and encouraging them to play with tools in a low-risk, virtual environment.

In the middle of the interest spectrum, youths who could be described as *Waverers* or *Explorers* would probably benefit from new physical spaces where they could play with technology and have access to mentors or peers with expertise to answer questions and provide feedback. *Explorers,* youths who have acquired some skills and confidence but have not yet found the right match, could benefit from open studios that provide a range of equipment, ideas, and peer-support networks to encourage exploration and development. Although we know to some extent that this kind of exploration and encouragement can happen in a virtual environment, most practitioners believe that initial experiences should be tied to physical environments where youths can build relationships with professional artists before migrating to online environments.

At the opposite end of the spectrum, we must consider ways to leverage the interest of youths considered *Directors,* those who already are developing portfolios and skills. Small grants through Kickstarter.com campaigns could service youths at this stage of development who often have ideas for projects but need additional resources to pursue them. Events such as Emoti-Con, the annual festival for NYC-area youth and digital media programs, seem worthy of support because they offer motivational deadlines and opportunities to exhibit work to a broader audience. In addition, Emoti-Con is run almost entirely by youths, which allows for leadership opportunities.

To inform these decisions, additional ethnographic work with illustrative case studies is needed. Some compelling questions worthy of further study include who opts in or out of available opportunities, what are the key entry points for arts learning, and which structures and communities support low barriers to entry. Furthermore, we need to take seriously our commitment to these progression pathways because they have serious ramifications for the lives of youths. As Shirley Brice Heath points out in the report, "Champions of Change" (Fiske, 1999), there is a need for a longer-term commitment to youth (a three-year minimum) in our efforts—not just to engage them in arts activities, but to see them through.

What we can do now:

1. Investigate the extent to which current research on the progression pathway model in interest-driven arts learning applies within virtual environments, completely informal environments, non-formal environments and digital/physical hybrid ecologies. Determining the stages of activity, the nature of progressions between levels, and the activities within each level should be considered in this investigation.

2. Identify a set of strategies for engaging youths with a range of interests in making and doing art.

3. Support events that provide highly engaged youths with opportunities to exhibit their work to a broader audience and support youth involvement in the creation and direction of these events.

4. Support additional ethnographic work that will build our understanding of participation in interest-driven arts learning over time, including who opts in and out, what are the key entry points, and how communities can address low barriers to entry.

5. Support research about the key differences between making and playing video games and the kinds of dispositions cultivated in each of these activities. Currently, much attention has focused on games within learning spaces and not creative production.

Conclusions

The main aim of this report has been to review key directions in the literature on interest-driven learning and address what they might mean to the arts today. We know that youth are spending an enormous amount of time online and in interest-driven activities with the arts at their core, and we argue in this report for the need to capitalize on these interests and connect these experiences to more formal arts learning opportunities. At the same time, youth have much to teach us about learning and innovative digital art practices, products, and processes that could equally inform our conversations. Building on this foundation, this report seeks to inspire new pedagogical practices, the design and study of new and existing learning environments, new tools to support the documentation of interest-driven arts learning, and further research in this area. This work carries a particular

imperative for youth whose prospects of attending arts schools or pursuing arts-based career paths are often crippled by the decline of arts offerings in their schools. By leveraging the multiple means of media to which youth are already exposed, we can open up new pathways into arts learning in a digital age.

APPENDICES

The following appendices provide descriptions of communities, applications, and online technology platforms to support interest-driven arts learning. Resources that we find especially worthy of exploration are highlighted in each table. In the right column, the cost of participation or purchase is summarized:

-- = free $ = minimal costs $$ = ~$25 $$$ = ~$50 or more

Appendix A: Communities that support interest-driven digital arts learning

Communities	Website	Description	Cost
MoMA	moma.org/learn/teens/index	Free classes and free Teen Nights	-- to $$$
Adafruit Industries	adafruit.com	Unique and fun DIY electronics and kits	--
Adler Planetarium	adlerplanetarium.org	3D modeling of the space	--
All Poetry	Allpoetry.com	Users can share poetry and provide informal feedback to each other	-- to $
Alldayplay	alldayplay.fm	Young deejays share song mixes, online radio shows and other music projects	--
Aviary	aviary.com	Free photo-editing software that offers many of the same features as costly professional tools	--
Bay Area Video Coalition (BAVC)	bavc.org	A nonprofit center that offers new media training and support to teens	$$$

Behance	behance.net	A free website where teens can showcase their visual arts portfolios	--
Brave New Voices	bravenewvoices.org	An annual youth poetry slam created by Youth Speaks	--
Brickfilms	brickfilms.com	An online community dedicated to brickfilming, which is the creation of stop motion films using plastic toys such as LEGO®	--
Bricks in Motion	bricksinmotion.com	An online forum and directory of brickfilming projects	--
ccMixter	ccmixter.org	A community music site featuring remixes licensed under Creative Commons	--
Children's Museum of Indianapolis	childrensmuseum.org/maps	A Museum Apprentice Program for youth ages 13 to 18	-- to $$$
CLICK	click.si.edu	A Smithsonian Photography Initiative including a collection of original essays, stories, and images	-- to $
Comic Con	comic-con.org	The largest comic convention in the world, where many amateur artists sell their work	-- to $$$
Computer Clubhouse	computerclubhouse.org	An international out-of-school learning environment focusing on underserved youths	--
Concept Art	conceptart.org	A digital arts magazine	--

Cosplay.com	cosplay.com	A free online forum for the cosplay or "costume play" community	--
CRAFT	blog.makezine.com/ craftzine	An online compilation of projects, blogs, videos, and events for DIY crafters	--
Create Digital Music	createdigitalmotion.com	A music and animation blog	--
Creative Teens	creativeteens. deviantart.com	An online community of teen photographers sharing and comment-ing on one another's work	--
CTG Music Community	ctgmusic.com	Offers the music community a forum to discuss current trends, questions, and offers support	--
Dance-Tech	dance-tech.net	An international community of artists, scientists, theorists and organizations exploring the intersec-tion of performance, media and culture	--
DarkPoetry.com	darkpoetry.com	A poetry-sharing and social networking site	-- to $$$
Deviant Art	deviantart.com	An exhibition and discussion space for photography, digital art, traditional art, folklore, film, and Flash-based creations; among others, providing resources, tutorials, and stock photos for public use	-- to $$$

Digital Youth Network	digitalyouthnetwork.org	Teaches teens to communicate, collaborate, and create; and Remix World provides a forum where teens can share and critique videos, songs, podcasts, graphic designs, and more with assistance provided by adult mentors	--
Dorkbot	dorkbot.org	Hosted by Columbia University's Computer Music Center, supports "people doing strange things with electricity"	--
Educational Video Center	evc.org	This non-profit organization is "dedicated to teaching documentary video as a means to develop the artistic, critical literacy, and career skills of young people, while nurturing their idealism and commitment to social change."	--
EServer drama collection	drama.eserver.org	Contains a collection of original plays and screenplays, criticism and links to other sites concerned with theatre	--
Etsy	etsy.com	An online art-selling community	-- to $$$
Exploratorium	exploratorium.edu	Intertwines the arts and sciences; features include the tinkering studio, where artists share their eclectic creations, and driven, which shares true stories of inspiration and invention	--

Eye Fetch	eyefetch.com	A forum for visual artists, including photography; allows for discussion and critique of work	--
FabLabs	fab.cba.mit.edu	A collection of places for teens to invent, create, construct, plan, design projects... and leave with a product	--
Facebook	facebook.com	A social network where many teens digitally communicate through text, video, audio, or through visual arts such as posting photographs	--
Fan Fiction	fanfiction.net	Where participants can write their own versions of fiction and provide feedback	--
FanimeCon	forums.fanime.com	Provides a forum for discussion around topics found at the Fanime conference, including how to make costumes, a forum on gaming, and more	--
Fuel your Writing	fuelyourwriting.com/ 46-sites-for-fanfiction- of-all-types	Shares 46 sites for fan fiction writers of all types, including some recommended above	
Museum of the Moving Image	movingimage.us	A forum dedicated to film and movie production	--
Flickr	flickr.com	A free image and video hosting website, which includes many teen groups; participants can comment directly on posted materials, similar to DeviantArt and TeenInk	--

Fotki	fotki.com/us/en	An online sharing network for digital photographers (amateur and professional); provides printing services, forums, sharing interface, and photo management tools	-- to $$
Fotolog	us.fotolog.com	A website that enables people to post photos and receive feedback from around the world	-- to $$
Glogster	glogster.com	A digital media blog and forum that enables users to design, create, and post digital designs	-- to $$
Guerrilla Innovation	guerrilla-innovation.com	A grassroots community of designers in architecture, media, literature, and other fields who seek to share unusual innovations	--
Harry Potter Fan Fiction	harrypotterfanfiction.com	A fan fiction site dedicated to the book series by J.K. Rowling; users can share writing and provide feedback	--
Harvestworks Digital Media Arts Center	harvestworks.org	A nonprofit group that showcases artists using new technology	--
iCompositions	icompositions.com	A website for musicians to share compositions based on Garageband	-- to $
Instructables	instructables.com	Features DIY creations made with plastic building blocks	--
Kickstarter	kickstarter.com	A site that enables individuals to fund creative projects	--

Learning from YouTube	vectors.usc.edu/projects/ learningfromyoutube/ texteo.php?composite=18	An online video-book with text and videos, analyzing the reach and impact of YouTube videos primarily pro- duced by young people	--
Let the Words Flow	FictionPress.com	A fan fiction site where people can share and provide feedback about submissions	--
Linked IN	linkedin.com	An online community where people can net- work with others about jobs and careers and build business rela- tionships	--
Little Big Planet Forum	lbp.me	Online forum for users to post and comment regarding Little Big Planet creations	--
MAKE: Technology on your time	makezine.com	A compilation of projects, blogs, video tutorials, and events for self-proclaimed DIY technology makers	--
Maker Faires	makerfaire.com	A showcase of inven- tion, creativity and resourcefulness	--
Mashable	mashable.com	Dedicated to all genres of digital media and ways that people are mashing it together	--
Meetup	meetup.com	An online community that organizes groups across all interests to learn something, do something, or share something	-- to $$$
MET Museum	metmuseum.org/ events/teens	Provides a teen pro- gram featuring art events and classes for teens ages 11-18	-- to $$$

Minecraft Gallery	minecraftgallery.com	A community of 3D sculptures and/or artifacts created in Minecraft and built by users while construct-ing their 3D worlds	--
MTV	mtv.com	Site dedicated to videos related to music and dance	--
Museum of Fine Arts Boston	mfa.org/programs/ teens-programs	Teen Arts Council, where members create and produce teen-focused events, greet and give information to museum visitors, and create wall labels to accompany the muse-um's art collections	$$$
Music Theory	musictheory.net	A site dedicated to educating the music lover	--
Musical Futures	musicalfutures.org.uk	A community of teen music composers	--
My Space Music	myspace.com/music	Community site sharing news, videos, forums, blogs, and more related to music	--
MySpace	myspace.com	Social Network site	--
Newgrounds. com	newgrounds.com	An online community for sharing digital art and creations	--
No Media Kings	nomediakings.org	A how-to blog site for art and design	--
NUMU	numu.org.uk	A network of musicians who compose and record music	--
Otakon	otakon.com/community_ clubs.asp	A site created by fans, for fans, which provides a list of websites and forums for fans to explore and to share	--

Photo.net	photo.net	A site where digital photographers join to learn more about photography and share ideas; with access to a blog, galleries, and a critique forum	--
Photography 4 Teens	photography4teens. deviantart.com	A forum for teens to share their photography and comment on each other's work	--
Photoshop ...Disasters	psdisasters.com	A community of readers who share examples of professionally edited Photoshop "disasters"	--
Planet Kodu	planetkodu.com	A free game design software for Xbox; the community and forum where users post comments and questions and/or share their creations; includes tutorials and challenges for game designers	--
Rate My Drawings	ratemydrawings.com	An online gallery of drawings, which allows members to rate one another's work.	--
Ravelry	ravelry.com	A community for people who knit and crochet	--
Reel Works	reelworks.org	A teen-centric filmmaking site that helps participants tell their personal stories	--
Scraper Bikes	originalscraperbikes. blogspot.com	The site of a grassroots urban phenomenon in which teens fix, paint, modify and "trick out" bikes	--

Scratch	scratch.mit.edu	Programming software capable of creating anything from music videos to video games; also includes a community for users to gain feedback and ideas for future projects	--
ShowND	shownd.com	An online portfolio group and a source for more information about digital photography	--
Shutterspace	myshutterspace.com	Provides a space to connect with other digital photographers (both amateurs and professional); also allows for sharing of photos, videos & stories, critiques on photos, and discussion about photography techniques and gears	--
Smithsonian Online	si.edu	Smithsonian Online Galleries and activities for children/teens	-- to $
StopMotion Animation	stopmotionanimation.com	This is a community website for animators.	--
Squidoo	squidoo.com	An online community that brings together a collection of digital creations shared and organized by category, such as comics, fanfic, video games	--
Teen Ink	teenink.com	Shares magazines and books created by teenagers published through the non-profit organization Young Authors Foundation	--

Teens Photography	teens-photography. deviant art.com	A Deviant Art site for teens with the purpose of sharing digital photography	--
The New Museum	newmuseum.org	Contains more than 6,000 exhibition images, descriptions, publications, and a searchable database of artists, curators, and institutions associated with the New Museum's programming	-- to $$$
Twitter	twitter.com	A worldwide network for sharing comments	--
Vimeo	vimeo.com/cadetresearch	An online video-creating site that houses a forum where users can engage in discussion about how to improve their Vimeo creations	--
Watt Pad	wattpad.com	Discover a site that offers creative writers a community to write and share their works of art	
Whitney	whitney.org/Education-Teens	An art museum that has a teen program that embraces their interests online	-- to $$$
Yo-Yo Games	yoyogames.com/make	A place to make, play and share games	--
YOUmedia	youmediachicago.org	A space for youths to learn New Media skills through invention and application	--
Young Talented Teens	young-talented-teens. deviantart.com	Deviant Art population of teens sharing photography and critiquing each other's work	--

Youth Radio	youthradio.org	Youth Radio's media education, broadcast journalism, technical training and production activities, which provide unique opportunities in social, professional and leadership develop-ment for youth ages 14–24	--
YouTube	youtube.com	Online video-sharing community and a resource used to share acting, Machinima, and other genres of videos that might fall under the category of drama	--
Zeum	zeum.org	Hosted by San Fran-cisco's Children's Museum, a hands-on, multimedia arts and technology experience for kids	-- to $$$

Appendix B: Apps that support interest-driven digital arts learning

App Name	App Site	App Description	App Cost
ANIMATIONS AND COMICS			
Adobe Ideas	adobe.com/ products/touchapps.html	A digital sketchbook, where users can draw using multiple layers and drawing tools at no extra charge	$
Animation Creator HD	itunes.apple.com/us/app/ animation-creator-hd/ id363201632?mt=8	An app that allows users to create animations	$
Animation Desk	itunes.apple.com/us/app/ animation-desk-for-ipad/ id409124087?mt=8	An iPad app that allows users draw and create animations	$
Animation Studio	itunes.apple.com/us/ app/animation-studio/ id362956988?mt=8	An app that users can use to learn how to create animations	$
Bitcartel	bitcartel.com/ comicbooklover	An app that allows users to store, organize, and view comic books	--
APP MAKERS			
Apple Maker for iPhone	freeiphoneappmaker.com	An app for making apps	--
MIT App Inventor	appinventor.mit.edu	Invent apps via a browser	--
DRAWING, PAINTING, & 2D VISUAL ARTS			
Artisan	eodsoft.com/artisan.html	Provides users with brushes and other drawing tools	$
ArtRage	artrage.com	An app for painting	$

ArtStudio	itunes.apple.com/us/app/artstudio-for-ipad-draw-paint/id364017607?mt=8	An app that provides users the tools for sketching, painting and photo editing	$
Auryn Ink	itunes.apple.com/app/au-ryn-ink/id407668628?mt=8	Simulates watercolor painting	$
Brushes	brushesapp.com	An app for digital painting	$
Etch A Sketch	itunes.apple.com/us/app/etch-a-sketch-hd-for-ipad/id397537481?mt=8	Cartoons and doodling app that can upload masterpieces to Facebook, too	--
FluidFX	itunes.apple.com/us/app/fluid-fx/id383133211?mt=8#	Special effects art software	$
Harmonious	itunes.apple.com/us/app/harmonious./id363375481?mt=8	A smart sketchpad	--
iDoodle2 lite	itunes.apple.com/us/app/idoodle2-lite/id286247235?mt=8	A drawing app	--
iDraw	itunes.apple.com/us/app/idraw/id363317633?mt=8	Vector drawing and illustration app	$
Inspire Pro	itunes.apple.com/us/app/inspire-pro-painting-drawing/id355460798?mt=8	A painting app that simulates wet oil paint on canvas	$
Morpholio Trace	itunes.apple.com/us/app/morpholio-trace/id547274918?mt=8	An app for tracing any imported image and develop ideas in layers	----
Palettes	maddysoft.com/iphone/palettes	Powerful iOS productivity tool for creating and maintaining color palettes	--

ProCreate	itunes.apple.com/us/app/ procreate-sketch-paint- create./id425073498?mt=8	This app allows users to paint and draw	$
Sketchbook Pro	itunes.apple.com/us/ app/sketchbook-pro/ id364253478?mt=8	A professional-grade painting and drawing app for the iPad	$
Sketch Me! HD	itunes.apple.com/us/ app/sketch-me!-hd/ id410282607?mt=8	Provides a platform for photo editing and sketching.	$
SketchBook Express	itunes.apple.com/us/ app/sketchbook-express/ id404243625?mt=12	An app with high quality tools for sketching	--
SketchBook Ink	itunes.apple.com/us/ app/sketchbook-ink/ id526422908?mt=8	An app for drawing and sketching	$
Squiggles	itunes.apple.com/ us/app/squiggles/ id284927554?mt=8	An app for creating digital art	$
Wasabi Paint	itunes.apple.com/us/ app/wasabi-paint/ id364902360?mt=8	A 3D painting app for abstract and impression- ist artists; an immersive and tactile digital paint experience	$
ZenBrush	itunes.apple.com/ us/app/zen-brush/ id382200873?mt=8	An ink brush app that simulates using an ink brush to write or paint	$
MISCELLANEOUS			
LEGO® Creationary	itunes.apple.com/us/ app/lego-creationary/ id401267497?mt=8	Puts a fun new spin on Lego creations with a variety of games	--
MoMA	apple.com//webapps// entertainment//momaau- dioonmomawifi.html	An app for use within New York's Museum of Modern Art—provides tour information via iPad or iPhone	--

MOVIES & VIDEO EDITING			
iMovie	itunes.apple.com/us/app/ imovie/id377298193?mt=8	Allows users to make movies anywhere	$
Pinnacle	itunes.apple.com/us/ app/pinnacle-studio/ id552100086?mt=8	This app provides users a way to create movies and then share easily through YouTube, Facebook, Box, email, and more	$
Videolicious	videolicious.com	Software that turns a smartphone or iPad into a video recorder, mixer, and photo-storage site; allows people to collaboratively edit images and videos	--
MUSIC			
Beatwave	itunes.apple.com/ us/app/beatwave/ id363718254?mt=8	Allows users to compose music	--
Bloom HD	itunes.apple.com/app/ bloom-hd/id373957864	An instrument, to com- pose music and paintings	$
Djay	algoriddim.com/ djay-ipad	An app that turns into a mini recording studio	$$
Finger Piano	itunes.apple.com/us/ app/fingerpiano-for-ipad/ id367603417?mt=8	An app that simulates real piano playing with one finger	$
GarageBand	itunes.apple.com/ us/app/garageband/ id408980954?mt=12	An app for making live recordings, MIDI sequencing and arranging	$
Korg iElectribe	korg.com/ielectribe	An iPad synthesizer	$$
Looptastic	soundtrends.com// apps//looptastic_hd	An iPad app that lets users create, edit, and mix loops/mixes, with a unique feature that people edit and mix with- out stopping the music	--

MacJams (Music Making Community)	macjams.com	An online musical studio where musicians compose, share, and provide feedback	--
Mini Piano	itunes.apple.com/ gb/app/minipiano/ id289333900?mt=8	Simulates playing on a piano	--
OMGuitar Synth	itunes.apple.com/us/app/ omguitar-guitar-synth/ id413803615?mt=8	Guitar simulator	$
PatternMusic	patternmusic.com/ frontdoor/PatternMusic. html	Three music tools in one, users can create songs, play interactive polyphonic musical instruments, and change the melody or pattern	--
Seline Ultimate: Ergonomic Synth	itunes.apple.com/us/app/ seline-hd-music-instrument/id388640430?mt=8	Turns the iPad into a musical instrument and enables users to make and record music	$
Sonorasaurus	sonorasaurus.com	A deejay app for the iPad and iPod Touch	$$
Sounddrop	itunes.apple.com/ us/app/soundrop/ id364871590?mt=8	An app for composing music	--
Music Studio	xewton.com/ musicstudio/overview	An app that allows users to compose music	$
PHOTOGRAPHY & PHOTO EDITING			
Diptic	itunes.apple.com/us/app/ diptic/id377989827?mt=8	A photo editing app and photo collage creator	$
iPhoto	apple.com/ilife/iphoto	An app that edits and stores photographs	$$
Juxtaposer	itunes.apple.com/ us/app/juxtaposer/ id292628469?mt=8	Allows users to combine multiple pictures into fun photomontages quickly and easily	$

Layers Pro	itunes.apple.com/us/app/ layers-pro-edition-for- ipad/id368261644?mt=8	Allows user to integrate with Photoshop and doodle, draw on photos, or paint on the iPad	$
PhotoPuppet	itunes.apple.com/us/ app/photopuppet-hd/ id421738553?mt=8	An app for making custom puppets from images cut out of your photos	$
PhotoSplash	itunes.apple.com/us/ app/photo-splash/ id417582128?mt=8	Photo editing app that al- lows users to use selec- tive colorization effects	--
SCULPTURE AND 3D VISUAL ARTS			
iGlass 3D	itunes.apple.com/ us/app/iglass-3d/ id328258114?mt=8	A glassblowing simula- tion app	$
PHYZIOS Sculptor	itunes.apple.com/us/ app/phyzios-sculptor/ id318411544?mt=8	Create a sculpture by tapping on the screen after selecting one of several tools, includ- ing chisel, drill, file, and rotator	--
SculptMaster 3D	itunes.apple.com/ee/ app/sculptmaster-3d/ id322829690?mt=8	Create amazing digital sculptures by painting and carving clay-like material with fingers	$

Appendix C: Online platforms that support interest-driven digital arts learning

Name of Tool	Website	Description	Cost
ANIMATION			
Anasazi Stop Motion Animator	animateclay.com	Software that saves and plays back animations on the computer	--
Adobe Flash Player	adobe.com/products/flashplayer	Software to create flash animation	$$$
Bricksmith	bricksmith.sourceforge.net	Create virtual instructions for Lego creations on Mac OS	--
Dragonframe	dragonframe.com/blog	Provides high-end animation tools	-- to $$
Go!Animate	press.goanimate.com	Free online animation tool that enables everyone—no artistic ability required—to create and animate stories	--
Inchworm Animation	inchwormanimation.com	Software for Nintendo DSi to create animations, flipbooks, and more	$$
Pivot	pivot-stickfigure-animator.en.softonic.com	Custom animation software	--
Toonboom Animation-ish	toonboom.com/products/animationish	Tools for designing animations for movies, greeting cards, websites, presentations and school projects	$-$$$
Xtranormal	xtranormal.com	Create three-dimensional animated movies using characters and sets provided	-- to $$

COMICS			
Bonzoi	bonzoi.com	A place to create and publish comics, scrapbooks, novels, and more	--
Howtoons: Tools of Mass Construction	instructables.com/group/howtoons	An instructable showing how to make comics; supports a gallery of comics made by users	--
Make Beliefs Comix	makebeliefscomix.com	An online comic generator where users can design their own comic strips using several different languages	--
Pixton	pixton.com	Online comic designer and creator	--
Strip Generator	stripgenerator.com/strip/create	An online free comic generator	--
ToonDoo	toondoo.com	Software to help users create comics	--
Witty Comics	hwittycomics.com	An online, simple and free comic generator; has a library of images to choose from, frames to design, and text bubbles to incorporate in the design of your story	--
DANCE			
Dance Central for Xbox Kinect	dancecentral.com	An immersive dance video game that features and tracks full-body dance moves	$$
Dance Dance Revolution	ddrgame.com	Interactive dancing game for Playstation, Xbox, and Wii	$

Dance Masters for Xbox Kinect	kinectyourself.com/ dance-masters	Provides songs at a variety of difficulty levels; users can follow a lead choreographer while several indicators track movements	$$
iDance	idance.net	Dance community that shares over 1800 dance steps and moves via video clips.	-- to $
Just Dance for Wii	amazon.com/Just-Dance-Nintendo-Wii/ dp/B002MWSY3O	An interactive dancing game for the Wii	$$
FILMS			
Distrify	distrify.com	A film network to share custom films around the world and make money at the same time	-- to $$$
Dynamo Player	site.dynamoplayer.com	Online platform to share and promote films for the purpose of selling your film—when the film sells, a portion of the profits are shared with Dynamo Player	-- to $$$
Egg Up	eggup.com	A secure platform to advertise and promote your film	-- to $$
FILM Film-Global action project	global-action.org	View new media productions created by other youth with the purpose of social change	--
Gee Three	geethree.com	iMovie plug-ins for making transitions for films	$$ to $$$
iMovie	apple.com/ support/imovie	The Apple website for iMovie and support	$$$

iMovie Project	ischool.utexas.edu/ technology/tutorials/ graphics/imovie/ 1create.html	Hosted by University of Texas, a tutorial for making iMovies	--
Pinnacle	pinnaclesys.com/ publicsite/us/home	Movie editing software	$$$
GAMES			
3D Rad	3drad.com	Three-dimensional development software	--
Alice	alice.org/index.php	Educational software that teaches students computer program-ming in a 3D environ-ment	--
Architect studio	architectstudio3d.org/ AS3d/home.html	Provides information, tutorials, and tools to design buildings in a 3D environment	--
Atmosphir	okaydave.com/ atmosphir.html	An online hybrid game/ design tool for creating and sharing 3D adven-ture games	--
DIY: Wario Ware	wariowarediy.com	DIY site that lets users design, create, and share micro games	$
Game Salad	gamesalad.com	Lets users create and publish video games without code knowl-edge, using drag-and-drop technology	-- to $$$
Gamestar Mechanic	gamestarmechanic.com	Combines a game with a tutorial; allows users to earn sprites and create top-down or platform style games	--
Kodu Game Lab	fuse.microsoft.com/ project/kodu.aspx	Free game design software for Xbox; includes tutorials and challenges for learn-ing more about game design.	--

Little Big Planet 2 for Play Station	us.playstation.com/ games-and-media/ games/littlebigplanet-2-ps3.html	A video game that provides a platform to create and publish games	$$$
Maya	autodesk.com/products/ autodesk-maya/overview	A professional three-dimensional modeling and game development tool	$$$
Minecraft	minecraft.net	A three-dimensional sandbox video game	$$
Scratch	scratch.mit.edu	A platform for learning programming while designing and creating games, videos, storyboards, and animations	--
SecondLife	secondlife.com	An online, three-dimensional virtual world	$
Sploder	sploder.com	A variety of game makers, including a platform creator, a 3D mission creator, and a shooter creator	--
Stencyl	stencyl.com	Create amazing cross-platform games without code, using drag-and-drop technology	-- to $$$
The Sims	thesims.com/ en_US/home	A simulation game site	$$
MUSIC			
Acid Xpress	hacidplanet.com/ downloads/xpress	Music recording, editing, and mixing software	--
Cakewalk	cakewalk.com	Software for recording, editing, and mixing music	$$$

Circuit Benders	circuitbenders.co.uk	Shows users how to make musical "noise machines" recycling older, unusable machines	--
Create Digital Music	createdigitalmusic.com	A repository of every-thing computers, DIY, technology, and music.	--
General Guitar Gadgets	generalguitargadgets.com	How to build a guitar effect pedal; schematics, tech-niques, and kits are available	$$ to $$$
Guitar Hero	hub.guitarhero.com	A game that allows users to learn and play guitar	$$$
Impromptu	tuneblocks.com	A tool that lets users create and remix tunes	--
Korg DS10 for Nintendo DSi	korgds10synthesizer.com	A synthesizer tool that enables users to create music and jam with other DSi players, as well	$$
Mac Jams	macjams.com	An online studio for musicians to congre-gate, collaborate and critique each other	--
MusicTheory .net	musictheory.net	A music training site	--
Rock Band 3 For Xbox	rockband.com	Create bands and characters and com-pete with other players	$$
Rock Revolution by Nintendo	nintendo.com/games /detail/UCbUz-LZjM5I-LUrHs5dkoSZR1c-7GwMw	Create your own music in a multi-track studio	$$
Smart Music	smartmusic.com	Interactive software for band, orchestra, and voice	$$

Songster	songsterr.com	An archive of guitar, bass, and drum tabs, collected and maintained by music lovers	--
Soundcloud	https://soundcloud.com	A platform for creating and sharing music; the timed comments feature lets people offer feedback at precise points in the music	-- to $$$
Band-in-a-Box	pgmusic.com	An app to compose music	$$$
Flexi Kids Music Composer	fleximusic.com/product/fleximusic-kids-com-poser	An app to compose music	$$
Ultimate Guitar	ultimate-guitar.com	A repository of more than 300,000 guitar and bass tablatures of popular songs	$
PHOTOGRAPHY			
Adobe Elements	adobe.com/products/photoshop-elements.html	Photo editing software for beginners	$$$
Adobe Photoshop	adobe.com/products/photoshop.html	Photo editing software for more advanced editing skills	$$$
Be Funky	befunky.com	An online photo-editing platform	
Foto Flexer	fotoflexer.com	An online photo-editing platform that allows users to manipulate the photos without purchasing software	--
gimp	gimp.org	Free photo-editing software	--
Photochopz	photochopz.com/forum	Provides tools and a community component for photo editing	--

VISUAL ARTS			
Butterapp	dev.butterapp.org	An online tool that allows the insertion of Web content such as maps and websites into movies; content appears as pop ups during viewing	--
Art Academy by Nintendo	artacademy.nintendo.com	A portable art tutor that teaches painting and drawing techniques from the Nintendo DS™ series system	$$
Corel Draw	corel.com/corel/product/index.jsp?pid=prod4260069&cid=catalog20038&segid=5700006&storeKey=us&languageCode=en	Digital drawing tool	$$$
Drawn to Life by Nintendo	nintendo.com/games/detail/g6dPuD1gDlCf-hJICdJxT0YwAcSuOHhi5	A versatile advanced drawing game.	$$
Imagine Artist by Nintendo	nintendo.com/games/detail/D-9uVzsO4WhIFD-jzTsS7602BNHqf_U4i	A Nintendo video game that allows users to practice using different digital mediums	$$
Lego Mindstorms	mindstorms.lego.com/en-us/Default.aspx	A three-dimensional building and programming kit	$$$
Lily Pad Arduino	arduino.cc/en/Main/ArduinoBoardLilyPad	A microcontroller board designed for wearable e-textiles that are programmable by the designer	$$$
Mashup Arts	mashuparts.com	A free tool to create online greeting cards with photos, videos, and music	--

Modkit	modk.it	An in-browser graphical program-ming environment for microcontrollers	$$ to $$$
Screenium	syniumsoftware.com/ screenium	Enables users to record what is happen-ing on the computer screen and then save and post to online communities	$$
Star Logo TNG	education.mit.edu/ projects/starlogo-tng	A tool to create and understand simula-tions of complex systems	--
XNA Games	msdn.microsoft.com/ en-us/aa937791.aspx	A game development tool	--

REFERENCES

Adams, J. (1999). Of mice and manga: Comics and graphic novels in art education. *Journal of Art and Design Education, 18,* 69–75.

Adams, J. C. (2007). *Alice, middle schoolers and the imaginary worlds camps.* Proceedings of the 38th SIGCSE Technical Symposium on Computer Science Education (pp. 307–311). New York, NY: ACM Press.

Allen, K., and Ingulsrud, J. E. (2003). Manga literacy: Popular culture and the reading habits of Japanese college students. *Journal of Adolescent and Adult Literacy, 46,* 674–683.

Arango, T. (November 25, 2008). Digital sales surpass CDs at Atlantic. *New York Times.* Retrieved July 6, 2009

Asmus, E. P. (1986). Student beliefs about the causes of success and failure in music: A study of achievement motivation. *Journal of Research in Music Education, 34,* 262–278.

Baafi, E., and Millner, A. (2011). *Modkit: A toolkit for tinkering with tangibles and Connecting Communities.* Proceedings of Tangible, Embedded, and Embodied Interaction (TEI).

Bamberger, J. (1991). *The mind behind the musical ear.* Cambridge, MA: Harvard University Press.

Barab, S., Dodge, T., Ingram-Goble, A., Pettyjohn, P., Peppler, K., Volk, C., and Solomou, M. (2010). Pedagogical dramas and transformational play: Narratively-rich games for education. *Mind, Culture, and Activity, 17*(3), pp. 1–30.

Barron, B. (2011). *Does making and creating matter?* Presentation at the 2011 American Educational Research Association (AERA) Conference. New Orleans, LA.

Basdekis, I., Klironomos, I., Antona, M., and Stephandis, C. (2006). *Online communities for all: The role of design for all in the formation and support of inclusive online communities.* Paper presented at the International Design for All Conference, Rovaniemi, Finland.

Baym, N. K. (1995). The emergence of community in computer-mediated communication. In S. G. Jones, (Ed.), *CyberSociety: Computer-mediated communication and community* (pp. 138–163). Thousand Oaks, CA: Sage Publications.

Bishop, J. (2005). *An ecological model for understanding and influencing behaviour in virtual communities.* Paper presented at the 1st International Congress on Post-Cognitivist Psychology Conference, Glasgow: University of Strathclyd.

Black, R. W. (2008). *Adolescents and online fan fiction.* New York: Peter Lang.

Boldt, G. (2009). Theorizing passionate love in reading: A social-psycho-analytic theory. *Pedagogies: An International Journal. 4*(4), pp. 246–263.

Brennan, K., Monroy-Hernandez, A., and Resnick, M. (2010). Making projects, making friends: Online community as catalyst for interactive media creation. *New Directions for Youth Development, 2010,* 75–83.

Bridge, S., (2006). Review [Review of the book *The animate! book Rethinking animation]. Animation, 3,* 91–96.

Brown, J. S., and Adler, R. (2008). Minds on fire: Open education, the long tail and Learning 2.0. *Educause Review, 43,* 17–32.

Buckingham, D. (2003). *Media education: Literacy, learning and contemporary culture.* Cambridge, UK: Polity Press.

Buckingham, D., and Burn, A. (2007). Game literacy in theory and practice. *Journal of Educational Mulitmedia and Hypermedia, 16,* 323–349.

Buechley, L., and Eisenberg, M. (2008). The LilyPad Arduino: Toward wearable engineering for everyone. Wearable Computing Column in *IEEE Pervasive, 7*(2), 12–15.

Buechley, L., Peppler, K., Eisenberg, M., and Kafai, Y. (2013). *Textile messages: Dispatches from the world of e-textiles and education.* New York: Peter Lang Press.

Burn, A. (2008). *The case of Rebellion: Researching multimodal texts.* In J. Coiro, et al. (Eds.). Handbook of research on new literacies (pp. 151-178). Mahwah, NJ: Lawrence Erlbaum.

Carey, P., Reid, C., and Kawasaki, E. (Guest). (January, 31, 2005). Manga, anime, and Japanese culture in America. *Talk of the Nation* [Radio broadcast]. National Public Radio

Cassell, J., and H. Jenkins (1998). *From Barbie to Mortal Kombat: Gender and computer games.* Cambridge, MA: MIT Press.

Catterall, J. S. (1995). *Different ways of knowing.* 1991–94 National Longitudinal Study Final Report.

Catterall, J. S. (2002). The arts and the transfer of learning. In R. J. Deasy (Ed.) *Critical links: Learning in the arts and student academic and social development* (pp. 151–157). Arts Education Partnership: Washington D.C.

Catterall, J. S. (2009). *Doing well and doing good by doing art: The effects of education in the visual and performing arts on the achievements and values of young adults.* Los Angeles, CA: Imagination Group/I-Group Books

Catterall, J.S., Dumais, S. A., and Hampden-Thompson, G. (2012). *The Arts and Achievement in at-risk youth: findings from four longitudinal databases.* National Endowment for the Arts, Washington, D.C. Retrieved from http://arts.gov.

Catterall, J.S., and Peppler, K. (2007). Learning in the visual arts and worldviews of young children. *Cambridge Journal of Education, 37,* 543–560.

Chang, J. (2005). *Can't Stop Won't Stop: A history of the hip hop generation.* New York: St. Martins Press

Chander, A., and Sunder, M. (2007). Everyone's a superhero: A cultural theory of "Mary Sue" fan fiction as fair use. *California Law Review, 95,* 597–626.

Chandler-Olcott, K., and Mahar, D. (2003a). Adolescents' anime-inspired fanfictions: An exploration of multiliteracies. *Journal of Adolescent and Adult Literacy, 46,* 556–566.

Chandler-Olcott, K., and Mahar, D. (2003b). "Tech-savviness" meets multiliteracies: Exploring adolescent girls' technology-mediated literacy practices. *Reading Research Quarterly, 38,* 356–85.

Chong, WU. (2008). Research on path-planning of virtual characters in computer animation. *Journal of Computer Applications, 28,* 315–318.

Cole, M., and The Distributed Literacy Consortium (2006). *The fifth dimension.* New York: Russell Sage Foundation Press.

Congdon, K.G., and Blandy, D. (2003). Zinesters in the classroom: Using zines to teach about postmodernism and the communication of ideas. *Art Education, 56,* 44–52.

Csikszenmihalyi, M. (2008). *Flow: The psychology of optimal experience.* New York: Harper Perennial Modern Classics

Cunningham, H. (1998) Digital culture—the view from the dance floor. In J. Sefton-Green (Ed.), *Digital diversions: Youth culture in the age of multimedia* (pp. 128-148). London: UCL Press.

Davis, J. A., and Merchant, G. (2009). *Web 2.0 for schools: Learning and social participation.* New York: Peter Lang.

Deasy, R. J. (Ed.) (2002). *Critical links: Learning in the arts and student academic and social development.* Washington D.C.: Arts Education Partnership

Dewey, J. (1934/1980). *Art as experience.* New York: The Berkley Publishing Group.

Diakopoulos, N. , Luther, K., Medynskiy, Y. E., and Essa, I. A. (2007*).* Remixing Authorship: Reconfiguring the author in online video remix culture (Report No. GIT-IC-07-05). *Architectural Design.* Georgia Institute of Technology.

diSessa, A. (2001). *Changing minds: Computers, learning and literacy.* Cambridge, MA: MIT Press.

Dougherty, D. (2011a). The maker movement: Young makers and why they matter. Retrieved from http://www.youtube.com/watch?v=lysTo7-VVg0

Dougherty, D. (2011b). *We are makers.* TED talk. Retrieved from http://www.youtube.com/watch?v=mlrB6npbwVQ

EDC (2006). *Annual report: Transforming lives.* Waltham, MA: Education Development Center, Inc.

Eisner, E. W. (2002). *The arts and the creation of mind.* New Haven, CT: Yale University Press.

Engenfeldt-Nielsen, S. (2007). *Educational potential of computer games.* New York: Continuum.

Erstad, O., Gilye, Ø., and de Lange, T. (2007). Re-mixing multimodal resources: Multiliteracies and digital production in Norwegian media education. *Learning, Media and Technology, 32,* 183–198.

Fields, D. A., and Kafai, Y. B. (2010). Stealing from Grandma or generating cultural knowledge? Contestations and effects of cheating in Whyville. *Games and Culture, 5*(1), 64–87.

Fisherkeller, J. (2002). *Growing up with television: Everyday learning among young adolescents*. Philadelphia, PA: Temple University Press.

Fiske, E. (Ed.). (1999). *Champions of change: The impact of the arts on learning*. Washington, DC: The Arts Education Partnership and the President's Committee on the Arts and Humanities.

Forte, A., and Bruckman, A. (2008). Why do people write for Wikipedia? Incentives to contribute to open-content publishing. *Proceedings of 41st Annual Hawaii International Conference on System Sciences (HICSS)*.

Freedman, K. (2010). Rethinking creativity: A definition to support contemporary practice. Art Education, 63(2), 8-14.

Freedman, K., Heinjnin, E., Kallio-Tavin, M., Karpati, A. and Papp, L. (2013). Visual culture learning communities: How and what students come to know in informal art groups. *Studies in Art Education, 53*(2).

Gauntlett, D. (2007). *Creative explorations: New approaches to identities and audiences*. New York: Routledge.

Gauntlett, D. (2011). *Making is connecting: The social meaning of creativity, from DIY and knitting to YouTube and Web 2.0*. Malden, MA: Polity. Retrieved from http://www.makingisconnecting.org

Gauntlett, D. (2012). Enabling and constraining creativity and collaboration: Some reflections after Adventure Rock. *In content cultures: Transformations of user generated content in public service broadcasting*, London: I.B. Tauris.

Gee, J. P. (2003). *What video games have to teach us about learning and literacy*. New York: Palgrave Macmillan.

Gee, J. P. (2004). Learning by design: Games as learning machines. *Interactive Educational Media, 8*, 15–23.

Gee, J. P., and Hayes, E. R. (2009). *Women and gaming: The Sims and the 21st century learning*. New York: Palgrave/MacMillan.

Gershenfeld, N. (2005). *FAB: The coming revolution on your desktop—from personal computers to personal fabrication*. New York: Basic Books.

Giacquinta, J. B., Bauer, J., and Levin, J. E. (1993). *Beyond technology's promise: An examination of children's educational computing at home*. New York: Cambridge University Press.

Goodman, S. (2003). Teaching youth media: A critical guide to literacy, video production, and social change. New York: Teachers College Press.

Graham, Jefferson. (October 14, 2009). Musicians ditch studios for tech such as GiO for Macs. *U.S.A. Today.*

Greene, M. (1995). *Releasing the imagination: Essays on education, the arts, and social change.* San Francisco, CA: Jossey-Bass.

Green, L. (2002). *How popular musicians learn: A way ahead for music education.* Burlington, VT: Ashgate.

Guzzetti, B.J., and Yang. Y. (2006). Adolescents' punk rock fandom: Construction and production of lyrical texts. In J. Worthy, B. Maloch, J.V. Hoffman, D.L. Schallert, and C. Fairbanks (Eds.), *Fifty-fourth yearbook of the National Reading Conference* (pp. 198–210) Chicago: The National Reading Conference.

Guzzetti, B., Elliot, K., and Welsch, D. (2010). *DIY Media in the classroom: New literacies across content areas.* New York: Teachers College Press.

Halverson, E. R. (2010). Film as identity exploration: A multimodal analysis of youth-produced films. *Teachers College Record, 11,* 2352–2378.

Harel, I. (1991). *Children Designers: Interdisciplinary constructions for learning and knowing mathematics in a computer-rich school.* Norwood, NJ: Ablex.

Heath, S. B., and Soep, E. (1998). Youth development and the arts in the non-school hours. *Grantmakers in the Arts, 9,* 9–32.

Heidelberger, C. A., and Sarnikar, S. (2008). *Knowledge flow in online communities: A study of the relationship between knowledge complexity, online collaboration, and knowledge flow.* MWAIS 2008 Proceedings, Paper 13.

Hetland, L., Winner, E., Veenema, S., and Sheridan, K. M. (2007). *Studio thinking: The real benefits of visual arts education.* New York: Teachers College Press.

Hirsch, B. (2005). *A place to call home: Afterschool programs for urban youth.* New York: Teachers College Press.

Hull, G. A., and Schultz, K. (Eds). (2002). *School's out: Bridging out-of-school literacies with classroom practice.* New York: Teachers College Press.

Illich, I. (1973). *Tools for Conviviality.* London: Calder and Boyars.

Ito, K. (2005) A history of manga in the context of Japanese culture and society. *Journal of Popular Culture: 38*(3).

Ito, M., Baumer, S., Bittanti, M., et al. (2010). *Hanging out, messing around, and geeking out: Kids living and learning with new media.* Cambridge, MA: The MIT Press.

Jackson, H. (2009). Knowing photographs now: The knowledge economy of photography in the twenty-first century. *Photographies*, 2(2), 169–183.

Jenkins, H. (1992). *Textual poachers: Television fans and participatory culture.* New York: Routledge.

Jenkins, H. (2006). *Fans, bloggers, and gamers: Exploring participatory culture.* New York: Routledge.

Jenkins, H., with R. Purushotma, K. Clinton, M. Weigel, and A. Robison (2009). *Confronting the challenge of participatory culture: Media education for the 21st century.* Occasional Paper. Boston: MIT/MacArthur Foundation.

Jewitt, C., and Kress, G. R. (2003). *Multimodal literacy.* New York: Peter Lang Publishers.

Kafai, Y. B. (1995). *Minds in play: Computer game design as a context for children's learning.* Hillsdale, NJ: Lawrence Erlbaum Associates.

Kafai, Y. B. (1996a). Gender differences in children's constructions of video games. In P. M. Greenfield and R. R. Cocking (Eds.). *Interacting with video* (pp. 39-66). Norwood, NJ: Ablex Publishing Corporation.

Kafai, Y. B. (1998). Video game designs by children: Consistency and variability of gender differences. In J. Cassell and H. Jenkins (Eds.), *From Barbie to Mortal Kombat: Gender and computer games* (pp. 90–114). Cambridge, MA: MIT Press.

Kafai, Y. B. (2006). Constructionism. In R. K. Sawyer (Ed.) *The Cambridge Handbook of the Learning Sciences* (pp. 35–46). Cambridge: Cambridge University Press.

Kafai, Y., and Peppler, K. (2011). Youth, technology, and DIY: Developing participatory competencies in creative media production. In V. L. Gadsden, S. Wortham, and R. Lukose (Eds.), *Youth cultures, language and literacy. Review of Research in Education,* Volume 34. Thousand Oaks, CA: Sage.

Kafai, Y. B., Peppler, K., and Chapman, R. (Eds.) (2009). *The computer clubhouse: Creativity and constructionism in youth communities.* New York: Teachers College Press.

Kalaitzakis E., Dafoulas G., and Macaulay L. (2003) *Designing online communities: Community-centered development for intensively focused user groups.* Paper presented at the Proceedings of the 10th International Conference on Human–Computer Interaction. Crete, Greece.

Kerns, W. (2009, March 4). *Dancing with the Stars* raises interest in ballroom dancing. Lubbock Online. Retrieved from http://lubbockonline.com/stories/030409/fea_400884057.shtml

Kirschner, F. (2011). Machinima's promise. *Journal of visual culture, 10,* 19–24.

Knobel, M., Lankshear, C., and Lewis, M. (2010). AMV Remix: Do-it-yourself anime music videos. In M. Knobel and C. Lankshear (eds), *DIY media: Creating, sharing and learning with new technologies* (pp. 205–230). New York: Peter Lang.

Knobel, M. and Lankshear, C. (Eds.) (2010). *DIY media: Creating, sharing and learning with new technologies.* New York: Peter Lang

Kress, G. (1996). *Reading images: The grammar of visual design.* London: Routledge.

Kress, G., and van Leeuwen, T. (2001). *Multimodal discourse: The modes and media of contemporary communication.* New York: Oxford University Press.

Lanamäki, A., and Päivarinta, T. (2009). Metacommunication patterns in on-line communities. *Lecture Notes in Computer Science, 5621,* 236–245.

Leadbeater, C., and Miller, P. (2004). *The pro-am revolution: How enthusiasts are changing our society and economy.* London: Ethos.

Lenhart, A., and Madden, M. (2007). *Social networking websites and teens: An overview.* Washington, DC: Pew Internet & American Life Project.

Lenhart, A., Purcell, K., Smith, A., and Zickuhr, K. (2010). *Social media and mobile internet use among teens and young adults.* Washington, DC: Pew Internet & American Life Project.

Lepper, M. R., and Malone, T. W. (1987). Intrinsic motivation and instructional effectiveness in computer-based education. In R. E. Snow and M. J. Farr (Eds.), *Aptitude, learning, and instruction* (Vol. 3, pp. 107–141). Hillsdale, NJ: Laurence Eralbaum.

Levi, A. W., and Smith, R. A. (1991). *Art education: A critical necessity.* Champaign, IL: Illini Books.

Lewis, L., Black, R. W., and Tomlinson, B. (2009). Let everyone play: An educational perspective on why fan fiction is, or should be, legal. *International Journal of Learning and Media, 1,* 67–81.

Liechti, O., and Ichikawa, T. (1999). A digital photography framework supporting social interaction and affective awareness. *Handheld and Ubiqui-*

tous Computing: Lecture Notes in ComputerScience, 1707, 186–192.

Lievrouw, L.A. (2003). When users push back: Oppositional new media and community. In M. Huysman et al. (eds.), *Communities and Technologies* (pp. 391–405). Dordrecht, The Netherlands: Springer

Lievrouw, L.A. (2011). *Alternative and activist new media.* Cambridge: Polity Press.

Lievrouw, L.A. (2008). Oppositional new media, ownership, and access: From consumption to reconfiguration and remediation. *Media ownership: Research and regulation,* pp. 391–416. Cresskill, NJ: Hampton Press

Lindsay, E. (2013). The space between us: Electronic music + modern dance + e-textiles. In L. Buechley, K. Peppler, M. Eisenberg, and Y. Kafai (Eds.), *Textile messages: Dispatches from the world of e-textiles and education.* New York: Peter Lang

Loftus, E. F., and Loftus, G. R. (1980). On the permanence of stored information in the human brain. *American Psychologist, 35,* 409–420.

Loveless, A. (1999). A digital big breakfast: The Glebe School Project. In J. Sefton-Green (Ed.) *Young People, Creativity and New Technologies.* New York: Routledge.

Luckman, S., and Potanin, R. (2010). Machinima: Why think "games" when thinking "film"? In M. Knobel and C. Lankshear (Eds.), *DIY media: creating, sharing, and learning with new technologies* (pp. 135–160). New York: Peter Lang

Luther, K., Caine, K., Ziegler, K., and Bruckman, A. (2010a). Why it works (when it works): Success factors in online creative collaboration. *Proceedings of the 16th ACM International Conference on Supporting Group Work* (pp. 1–10).

Luther, K., Diakopoulos, Nicholas, and Bruckman, A. (2010b). *Edits and credits: Exploring integration and attribution in online creative collaboration.* Paper presented at the Proceedings of the ACM Conference on Human Factors in Computing Systems. Atlanta, GA.

Madhav, K. (2011). Real-time puppet animation with Kinect. *KinectHacks.* Retrieved from http://kinecthacks.net/real-time-puppet-animation-with-kinect

Malan, D. (2006). Scratch for budding computer scientists. Last accessed in June 2007 http://www.eecs.harvard.edu/~malan/scratch/printer.php

Maloney, J., Peppler, K., Kafai, Y. B., Resnick, M., and Rusk, N. (2008) *Programming by choice: Urban youth learning programming with Scratch*. Published in the proceedings by the ACM Special Interest Group on Computer Science Education, Portland, OR.

McBride, J. (2007). Hip hop planet. *National Geographic Magazine*. April 2007 issue. Available at http://ngm.nationalgeographic.com/2007/04/hip-hop-planet/mcbride-text

Merchant, G. (2010). Visual networks: Learning and photosharing. In M. Knobel and C. Lankshear (Eds.), *DIY media: Creating, sharing, and learning with new technologies* (pp. 79–102). New York, NY: Peter Lang.

Miller, K. (2009) Schizophrenic performance: Guitar Hero, Rock Band, and virtual virtuosity. *Journal of the Society for American Music, 4*, 395–429.

Mitchell, G., and Clarke, A. (2003). Videogame art: Remixing, reworking and other interventions. In *Level up: Digital games research association (DiGRA) Proceedings*, Utrecht University.

Moll, L. C., Amanti, C., Neff, D., and Gonzalez, N. (1992). Funds of knowledge for teaching: Using a qualitative approach to connect homes and classrooms. *Theory into Practice, 31,* 132–141.

Morrell, E. (2002). Toward a critical pedagogy of popular culture: Literacy development among urban youth. *Journal of Adolescent and Adult Literacy, 46*, 72–77.

National Research Council (1999). Being fluent with information technology. Washington, DC: National Academy Press.

The New London Group (1996). A pedagogy of multiliteracies: designing social futures. *Harvard Educational Review, 66*, 60–92.

New York Hall of Sciences. (2010). *Proceedings from the "Innovation, Education, and the Maker Movement" workshop*. Retrieved June 7, 2011 from http://www.nysci.org/learn/research/maker_faire_workshop

Noblit, G. W., and Corbet, D. (2001). *North Carolina charter school evaluation report*. (Deliverable to the North Carolina State Board of Education). Chapel Hill, NC: University of North Carolina at Chapel Hill. Available at http://www.dpi.state.nc.us/docs/data/reports/evalreport.pdf (last accessed October 29, 2013).

Nolan, M. E. (2005). Search for Original Expression: Fan Fiction and the Fair Use Defense. *S. Ill. ULJ, 30*, 533.

North, A. C., and Hargreaves, D. J. (1999). Music and adolescent identity. *Music Education Research, 1,* 75–92.

Palumbo, D. B. (1990). Programming language/problem-solving research: A review of relevant issues. *Review of Educational Research, 60,* 65–89.

Papert, S. (1980). *Mindstorms: children, computers, and powerful ideas.* New York, NY: Basic Books.

Papert, S. (1993). *The children's machine.* New York: Basic Books.

Parsad, B., and Spiegelman, M. (2012). *Arts education in public elementary and secondary schools: 1999–2000 and 2009–10* (NCES 2012–014). Washington, DC: National Center for Education Statistics, Institute of Education Sciences, U.S. Department of Education.

Peppler, K. (2007). Creative bytes: literacy and learning in the media arts practices of urban youth. Unpublished dissertation, University of California, Los Angeles.

Peppler, K. (2010a). Media arts: Arts education for a digital age. *Teachers College Record, 112*(8), 2118–2153.

Peppler, K. (2010b). The new fundamentals: Introducing computation into arts education. In E. P. Clapp and M. J. Bellino (Eds.) *20 under 40: Reinventing the arts and arts education for the 21st century.* Bloomington, IN: AuthorHouse.

Peppler, K., Downton, M., Lindsay, E., and Hay, K. (2011). The nirvana effect: Tapping video games to mediate music learning and interest. *International Journal of Learning and Media, 3*(1), 41–59.

Peppler, K., and Davis, H. (2010). *Arts and learning: A review of the impact of arts and aesthetics on learning and opportunities for further research.* Paper published in the proceedings of the International Conference of the Learning Sciences, Chicago, IL.

Peppler, K., and Kafai, Y. (2006). *Creative codings: Investigating cultural, personal, and epistemological connections in media arts programming.* Proceedings published in the 2006 International Conference of the Learning Sciences, Bloomington, IN.

Peppler, K., and Kafai, Y. (2007a). From SuperGoo to Scratch: Exploring creative digital media production in informal learning. *Learning, Media, and Technology, 32*(2), 149–166.

Peppler, K., and Kafai, Y.B. (2007b). *Collaboration, computation, and creativity: Media arts practices in urban youth cultures.* Proceedings published by the Computer Supported Collaborative Learning (CSCL) Conference held at Rutgers University, New Brunswick, NJ.

Peppler, K., and Kafai, Y. B. (2008). *Learning from krumping: Collective agency in dance performance cultures.* Paper published in the proceedings of the 2008 International Conference of the Learning Sciences (ICLS) held at the University of Utrecht, Utrecht, Netherlands.

Peppler, K., and Kafai, Y. B. (2010). Gaming fluencies: Pathways into a participatory culture in a community design studio. *International Journal of Learning and Media, 1*(4), 1–14.

Peppler, K., and Solomou, M. (2011). Building creativity: Collaborative learning and creativity in social media environments. *On the Horizon 19*(1), 13–23

Peppler, K., Danish, J., Zaitlen, B., Glosson, D., Jacobs, A., and Phelps, D. (2010). *BeeSim: Leveraging wearable computers in participatory simulations with young children.* Paper presented at the 9th International Conference on Interaction Design and Children, Barcelona, Spain.

Peppler, K., Warschauer, M., and Diazgranados, A. (2010). Game critics: Exploring the role of critique in game-design literacies. *E-learning, 7*(1), 35–48.

Perkel, D. (2006). *Copy and paste literacy: Literacy practices in the production of a Myspace profile.* Paper presented at the DREAM-Conference: Informal Learning and Digital Media: Constructions, Context, Consequences, Odense, Denmark, 21-23 September.

Perkel, D. (2010). The art of theft: Creativity and property on deviantART. Retrieved from http://blogs.nyu.edu/projects/material-world/2010/07/the_art_of_theft_creativity_an.html

Pink, D. (2011). *Drive: The surprising truth about what motivates us.* New York: Riverhead Books.

Pinkett, R. D. (2000). *Bridging the digital divide: Sociocultural constructionism and an asset-based approach to community technology and community building.* Paper presented in the 81st Annual Meeting of the American Educational Research Association, New Orleans, LA.

Potter, J. (2010). Photoshopping/photosharing: New media, digital litera-
cies, and curatorship. In M. Knobel and C. Lankshear (Eds.), *DIY me-
dia: Creating, sharing, and learning with new technologies* (pp. 103–134).
New York: Peter Lang.

Prensky, M. (2006). "Don't bother me mom—I'm learning!" St. Paul, MN:
Paragon House.

Price, D. (2006). *Supporting young musicians and coordinating musical pathways.*
London: The Paul Hamlyn Foundation.

Provenzo, E. F. (1991). *Video kids: Making sense of nintendo.* Cambridge, MA:
Harvard University Press.

Quillen, D. (2008). Rock Band and Guitar Hero turning gamers into musi-
cians says Guitar Center survey. 1up News. Available at http://www.1up.
com/do/newsStory?cId=3171507 (accessed March 19, 2009).

Rasula, J. (2009). From corset to podcast: The question of poetry now. *Amer-
ican Literary History, 21,* 660–673.

Reas, C., and Fry, B. (2006). Processing: programming for the media arts. *AI
and Society, 20,* 526–538.

Ren, Y., and Kraut, R. E. (2010). *Agent-based modeling to inform online com-
munity theory and design: Impact of discussion moderation on member commit-
ment and contribution.* MISRC Working Papers Series, 10(1).

Ren, Y., Harper, F. M., Drenner, S., Terveen, L., Kiesler, S., Riedl, J., and
Kraut, R. E. (2012). Building member attachment in online communi-
ties: Applying theories of group identity and interpersonal bonds. *MIS
Quarterly, 36*(3), 841-864.

Ren, Y., Harper, F. M., Drenner, S., Terveen, L., Kiesler, S., Riedl, J., and
Kraut, R.E. (2012). Building member attachment in online communi-
ties: Applying theories of group identity and interpersonal bonds. *MIS
Quarterly, 36*(3), 841–864.

Resnick, M. (2002). Rethinking learning in the digital age. In *The Global
Information Technology Report 2001–2002* (pp. 32-37). Oxford: Oxford
University Press.

Resnick, M. (2006). Computer as paintbrush: Technology, play, and creative
society. In D. G. Singer, R. M. Goinkoff, and K. Hirsh-Pasek (eds.), *Play
= learning: How play motivates and enhances children's cognitive and social-
emotional growth* (pp 192-208). New York: Oxford University Press.

Resnick, M. Maloney, J., Monroy-Hernandez, A., Rusk, N., Eastmond, E., Brennan, K., Millner, A., Rosenbaum, E., Silver, J., Silverman, B, and Kafai, Y. (2009). Scratch: programming for all. *Communications of the ACM, 52*(11), 60–67.

Rheingold, H. R. (1993). *The virtual community: Homesteading on the electronic frontier.* New York: Addison-Wesley.

Richey, D., and Kratzert, M. (2006)."I too dislike it":The evolving presence of poetry on the internet. *Evolving Internet Reference Resources, 41.* New York: Routledge

Rideout,V., Foehr, U., and Roberts, D. (2010). Generation m2: Media in the lives of 8- to 18-year-olds. Menlo Park, CA: Kaiser Family Foundation.

Ryberg, T., and Larsen, M. C. (2008). Networked identities: understanding relationships between strong and weak ties in networked environments. *Journal of Computer Assisted Learning, 24,* 103–115.

Salen, K. (2008). Toward an ecology of gaming. *The Ecology of Games: Connecting Youth, Games, and Learning.* The John D. and Catherine T. MacArthur Foundation Series on Digital Media and Learning. Cambridge, MA:The MIT Press.

Salen, K., and Zimmerman, E. (2003). *Rules of play: Game design fundamentals.* Cambridge, MA:The MIT Press.

Salter, C. (2007). Girl power. *Fast Company:* September 2007. Available at: http://www.fastcompany.com/magazine/118/girl-power.html

Schwabach, A. (2008).The Harry Potter lexicon and the world of fandom: Fan fiction, outsider works, and copyright. *U. PITT. L. REV., 70* (September), 387.

Schwartz, A., and Rubinstein-Ávila, E. (2006). Understanding the manga hype: Uncovering the multimodality of comic-book literacies. *Journal of Adolescent and Adult Literacy, 50,* 40–59.

Scott, A. K. (2011). Futurism: Cory Arcangel plays around with technology. *New Yorker* pp. 30–34.

Sefton-Green, J. (2006). *New spaces for learning: Developing the ecology of out-of-school education.* Hawke Research Institute Working Paper Series, No. 35.

Sefton-Green, J., and Buckingham, D. (1998). Digital visions: Children's "creative uses" of multimedia technologies. In J. Sefton-Green (ed.), *Digital*

diversions: Youth culture in the age of multimedia. London: UCL Press.

Sefton-Green, J., Thomson, P., Jones, K., and Bresler, L. (2011). *The international handbook of creative learning.* London: Routledge.

Sheridan, K. (2011). Envision and observe: Using the Studio Thinking Framework for learning and teaching in the digital arts. *Mind, Brain and Education, 5*(1), 19–26.

Shirky, C. (2008). *Here comes everybody: The power of organizing without organizations.* London: Penguin.

Shirky, C. (2011). Course syllabus for the design of conversational spaces. Retrieved June 7, 2011 from http://journalism.nyu.edu/assets/Syllabi/2011/Fall/Conversation-Syllabus.doc

Smith, B. K. (2006). Design and computational flexibility. *Digital Creativity, 17*(2), 65–72.

Smith, J. (2004). I can see tomorrow in your dance: A study of *Dance Dance Revolution* and music video games. *Journal of Popular Music Studies, 16,* 58–84.

Snickars, P., and Vonderau, P. (Eds.). (2009). *The YouTube reader.* London, UK: Wallflower Press.

Soep, E. (2005). Critique: Where art meets assessment. *Phi Delta Kappan 87*(1), 38–63.

Soep, E., and Chavez, V. (2005). Youth radio and the pedagogy of collegiality. *Harvard Educational Review, 75,* 409–434.

Spencer, A. (2005). *DIY: The rise of lo-fi culture.* London: Marion Boyars Publishers.

Steinkuehler, C. (2008). Cognition and literacy in massively multiplayer online games. In J. Coiro, M. Knobel, C. Lankshear, and D. Leu (Eds.), *Handbook of research on new literacies* (pp. 611–634). New York: Laurence Earlbaum.

Thomas, A. and Tufano, N. (2010). Stop motion animation. In M. Knobel and C. Lankshear (Eds.), *DIY media: Creating, sharing, and learning with new technologies* (pp. 161–184). New York: Peter Lang.

Torff, B. (2002). A comparative review of human ability theory: Context, structure and development. In R. Colwell (Ed.) *MENC handbook of musical cognition and development.* Oxford: Oxford University Press.

Torrey, C., McDonald, D. W., Schilit, B. N. and Bly, S. (2007). *How-to pages: Informal systems of expertise sharing.* In Proceedings of the Tenth European Conference on Computer Supported Cooperative Work. ECSCW '07, 391–410.

Vered, K. O. (2008). Children and media outside the home: Playing and learning in after-school care, London: Palgrave.

Wang, C., and Burris, M. (1994). Empowerment through photo novella: Portraits of participation. *Health Education Quarterly, 21,* 171–186.

Warschauer, M., and Matuchniak, T. (2010). New technology and digital worlds: Analyzing evidence of the equity in access, use and outcomes. *Review of Research in Education, 34*(1).

Wiggins, J. (2009). *Teaching for musical understanding.* (2nd Ed.). Rochester, MI: Center for Applied Research in Musical Understanding.

Wilson, S. M., and Peterson, L. C. (2002). The anthropology of online communities. *Annual Review of Anthropology, 31,* 449–467.

Wootton, K. (2004). Community this and community that. In Smyth, L. and Stevenson, L. *You want to be part of everything: The arts, community, and learning.* Washington, DC: Arts Education Partnership.

Wright, W. (2006, April). Dream machines. *Wired Magazine.* Retrieved from http://www.wired.com/wired/archive/14.04/wright.html

Zervos, K. (2007). The virtualization of poetry and self. *epoetry.paragraphe. info,* 1–16.

AUTHOR BIO

Kylie Peppler is an assistant professor of Learning Sciences Program at Indiana University. An artist by training, she engages in research that focuses on the intersection of arts, media, new technologies, and informal learning. Peppler's dissertation work on the study of the media-rich programming environment Scratch resulted in the book, *The Computer Clubhouse: Constructionism and Creativity in Youth Communities*. Peppler has since collaborated with Leah Buechley, Yasmin Kafai, and Mike Eisenberg to study e-textiles, which resulted in the forthcoming co-edited volume titled, *Textile Messages: Dispatches from the World of E-Textiles and Education*. Her current work on creativity, computation, and media arts in youth communities is supported by the National Science Foundation and the John D. and Catherine T. MacArthur Foundation.

CONTACT INFORMATION
Kylie Peppler
www.kpeppler.com
kpeppler@gmail.com

Colin Lankshear & Michele Knobel

General Editors

New literacies emerge and evolve apace as people from all walks of life engage with new technologies, shifting values and institutional change, and increasingly assume 'postmodern' orientations toward their everyday worlds. Despite many efforts to take account of such changes, educational institutions largely remain out of touch with the range of new ways of making and sharing meanings that increasingly mediate and shape the lives of the young people they teach and the futures they face. This series aims to explore some key dimensions of the changes occurring within social practices of literacy and the educational challenges they present, with a view to informing educational practice in helpful ways. It asks what are new literacies, how do they impact on life in schools, homes, communities, workplaces, sites of leisure, and other key settings of human cultural engagement, and what significance do new literacies have for how people learn and how they understand and construct knowledge. It aims to challenge established and 'official' ways of framing literacy, and to ask what it means for literacies to be powerful, effective, and enabling under current and foreseeable conditions. Collectively, the works in this series will help to reorient literacy debates and literacy education agendas.

For further information about the series and submitting manuscripts, please contact:

Michele Knobel & Colin Lankshear
Montclair State University
Dept. of Education and Human Services
3173 University Hall
Montclair, NJ 07043
michele@coatepec.net

To order other books in this series, please contact our Customer Service Department at:

(800) 770-LANG (within the U.S.)
(212) 647-7706 (outside the U.S.)
(212) 647-7707 FAX

Or browse online by series at:
www.peterlang.com